NOW YOU CAN TAKE MY PICTURE

sharing cultural interchanges

MIKE HARRIS

Introduction by Eddie Soloway

Mike
Choate '59

NOW YOU CAN TAKE MY PICTURE
Mike Harris

Published by Mike Harris Photography
39 Stanwich Road
Greenwich, Connecticut 06830
mikeharrisphotography.com

Edited by Michael McWeeney
Text edited by Eileen AJ Connelly

Printed in Canada by Friesens

First Edition 2022

ISBN number 978-0-578-94903-1
BISG Codes: PHO000000, PHO011010, PHO023090

This is a book about two loves: my wife Sally and our passion for photography.

I dedicate this book to Sally.

Introduction by EDDIE SOLOWAY

If you met the people whose photographs you are about to see, chances are good they would remember Mike Harris. They would remember the guy who asked about their lives, who listened to what they said, and with whom they shared a laugh.

Mike goes way beyond snapping a picture with a long lens and walking by. I am convinced that would leave him empty. When you watch Mike in action, he leads with a smile and a "Hi." He genuinely wants to know more about you. That doesn't mean he isn't thinking about all the photographic elements — sweet light as Enos Bender enters his church, multiple elements unfolding on a Coney Island beach, a refreshing composition of people waiting for buses in Camaguey, Cuba, and a fun play of color abstractions in a Oaxacan café — but he makes these important photographic decisions while engaging and paying attention to the moving world around him.

True photography secrets get overshadowed by an obsession with cameras and software. The myth that bigger and faster are better can distract from the skills of seeing, being curious, and caring about your subject.

Mike also knows another big secret to making your own unique photographs: Go your own way. If a group of photographers is following a leader down the street like little ducklings, not only will the photographs all look alike, but Mike won't be there. He will have slipped off to find his own moments. Just have a look at how he plans his trips! He goes to Clarksdale, Mississippi, and heads into the Ground Zero Blues Club. Not only does he make friends and photographs, but he also gets invited to church the next morning. He stops into an Iowa visitor center and leaves with an invitation to that evening's local homecoming game, along with access to photograph on the field. Or how about Mike's multi-year friendship with the Yoder family in Springs, Pennsylvania? Read his story, because it is full of what is right in photography. After an initial visit to an Amish community, he wrote a letter — remember those? — which led to years of repeat visits with the family. He brought back prints, stayed in touch, and acted as a friend on numerous occasions without making a photograph. Look at the portraits of Tillie and Daniel, and you will see trust in their eyes. Trust in someone who spent time and cared.

Finally, Mike has a great sense of humor. You can see it in his photographs — have a look at the two that share a double-page spread — Risqué Business and Tail of the Dog. When you are right there with him, you can see it in his eyes. He might show you a photograph and wait for you to catch the hidden punchline. And, if you ever want to tease him, I highly recommend putting on your straight poker face, and while looking at one of his photographs, perhaps on his laptop over a glass of wine, say, "That's nice. It's almost as interesting as Sally's."

Mike and his soulmate, Sally, have enriched my life, and they have touched the hearts of so many people they have met on their journeys around the world. I am thrilled by their passion for seeing the world and spreading that joy to all of us.

Enjoy this journey into Mike Harris' world.

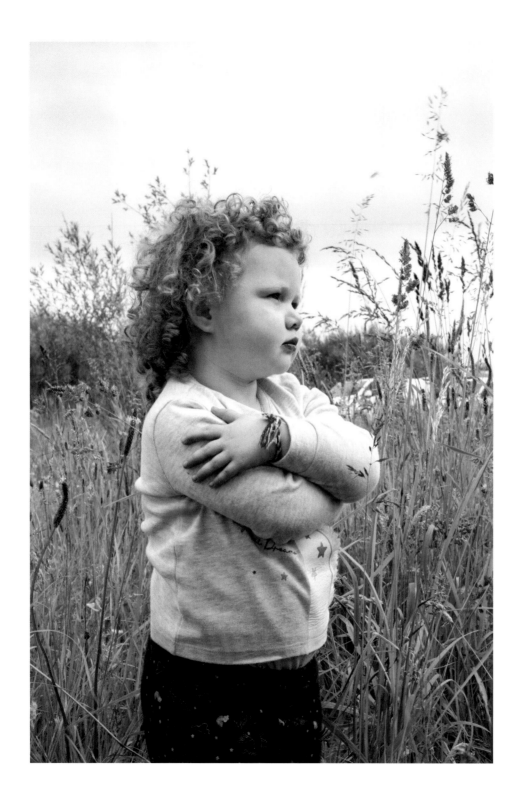

Pouting Irish Traveller Girl - Roadside Camp, Ireland - June 2019

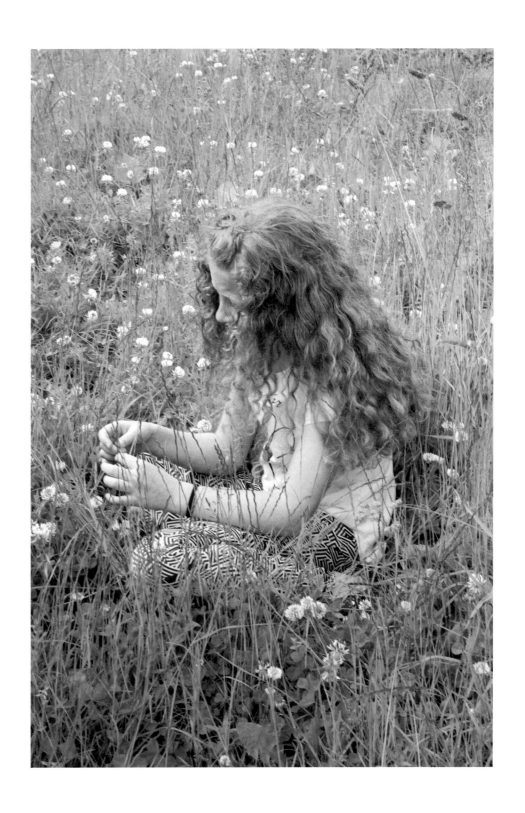

A Reflective Moment - Cashel, Ireland - June 2019

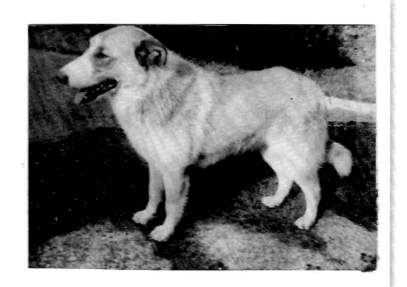

Preface by MIKE HARRIS

Sally and I married on November 28, 1998. We are inseparable, sharing every moment together. Early on, we each enjoyed taking typical pictures of family members and vacations.

Deciding in 2007 that I wanted to improve my photography. I began researching numerous workshops, and it became obvious that Eddie Soloway was the person to work with. With some trepidation, I approached Sally with the idea of my spending a week to attend Eddie's workshop, "Essence of Place" in San Miguel, Mexico. Sally was entirely supportive.

That week with Eddie opened my eyes to the concept that photographs can tell a story about a place, a culture, and how that culture "speaks" to the photographer. Eddie patiently nurtured my ability to see and interpret what I saw through my photographs. I was in tears when, at the end of an exhausting week, I called Sally to tell her that these seven days had changed my life.

Eddie occasionally organized events for workshop alumni, and he included spouses on a special trip to Venice. Sally came along, and Eddie proceeded to work his magic on her. Sally was hooked. Ever since that trip, much of our life together has focused on photography. Having Sally as my partner in this obsession adds joy to my life.

Nothing feels better to me than heading out, camera in hand, eyes wide open, searching for that perfect photograph. Sometimes it's right there in front of me. Sometimes it's hard to see, but that is the thrill of the hunt. Spot that opportunity, and it is like a rush of adrenaline.

That rush recalls the feeling I had as a child, when I would tote my Kodak Brownie outside and snap rather random pictures of my best friend, Donnie. I should note that Donnie was also my favorite dog. Although only one or two photos still exist from those early days, I still recall in detail the camera, the process of clicking the shutter, turning the knob to the next frame and anxiously awaiting the return of the pictures from the local drugstore. The stage was set for the future.

We have come to realize that we get the most pleasure when we photograph people and the cultures in which they live. Our cameras have a way of breaking the ice. We love the relationships we build with our subjects, even if they are fleeting.

Taking photographs is more than just seeing a nice image and squeezing the shutter. I need to connect with the subject, feel how it affects me. My photographs then say something about me. In effect, I am a part of each one. I hope that comes through in the images I have selected for this book.

I enjoy sharing the story of how, or why, I took a particular photograph, why that image is meaningful to me, and I have chosen to share stories for selected photos in this book.

People are often curious whether I ask for permission before taking a photo. If the action is fleeting, the answer is no. Take the photo while you can. Often, it is obvious you are taking a photo and the subject is implicitly consenting. Other times I speak with the subject and specifically ask for permission. Looking at photographs in this book, you can determine for yourself which approach I used.

Once in a while, the subject says "No." While I honor that desire, I will often chat, hoping that the person's mind will change. Sometimes no, but sometimes yes. One such "yes" came from the Navajo woman who is the subject of the photograph on the next page. She changed her mind and said, "Now You Can Take My Picture."

It was August 2017 and Sally and I had been traveling on Route 66 for quite a while. We always try to experience the local atmosphere when we travel, and we stayed in motels and ate in diners and dives as we drove west on the Mother Road. In Gallup, New Mexico, pawn shop capital of the nation, we treated ourselves to an historic inn, the El Rancho, where movie stars stayed when filming the latest western. The Olivia de Havilland room was ours for the night.

Gallup is also the border town on the edge of the Navajo Reservation.

Late that afternoon, we wandered downtown, big cameras hanging over our shoulders. A loud voice called out, "Don't take my picture!" It stopped me in my tracks, and I assured the Navajo woman that I would not.

We started chatting, and she offered some ideas on what local activities might interest us. I noticed something I felt was unusual about the woman. I said, "You must miss him." She asked what I meant, and I pointed to her t-shirt, which had a photo of Barack Obama on it and the words "Presidential Inauguration." She said "Yes, I miss him. I miss him a lot." I replied,"You can't miss him any more than I do." With that she came over and we embraced. It lasted just a second or two. She then stepped back, pumped her fist in the air and proclaimed, "Now you can take my picture." I took just one shot. It certainly is not the best photo from the trip, but it means more to me than any other.

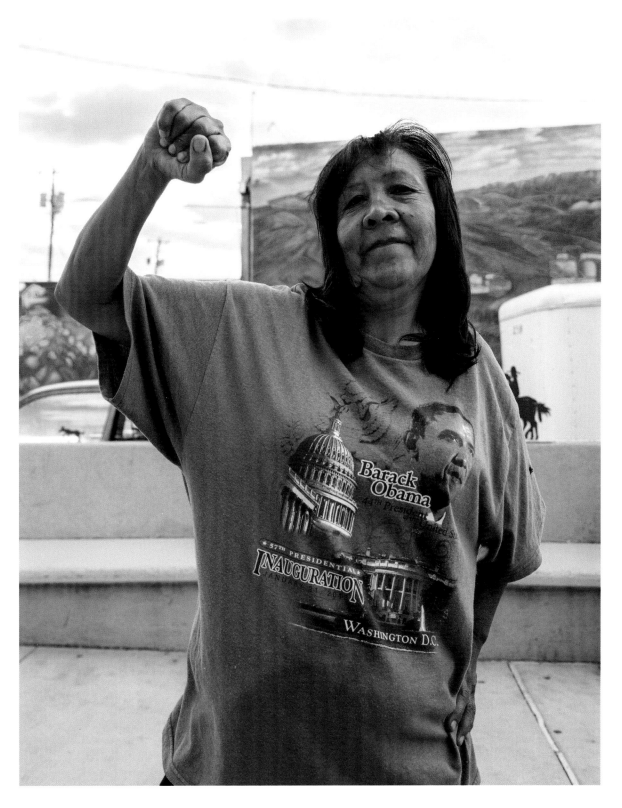

Political Navajo - Gallup, New Mexico - August 2017

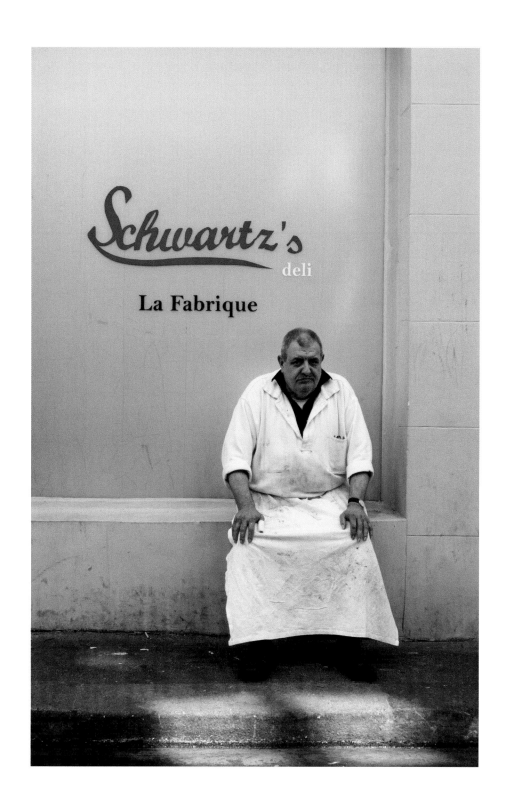

Butcher on a Break - Paris, France - May 2012

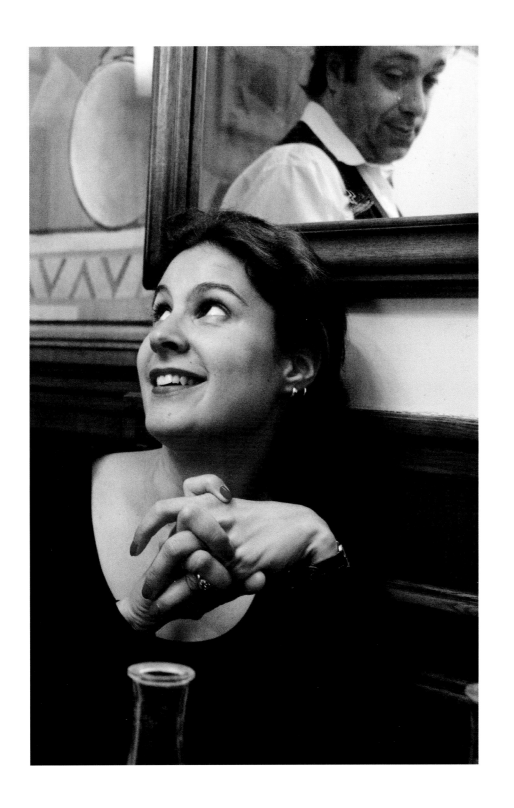

Connecting with the Waiter - Paris, France - May 2012

Peter Turnley, photographer
Paris, France

Mike Harris connects his eyes with his heart which is full of compassion, kindness, sincerity, elegance, wisdom, perspective, and most importantly humanity. His photographs draw us in to moments that one can feel and remind us of the beauty of our worldwide human family.

I have had the pleasure to spend time with Mike in Paris and Buenos Aires and his embrace of all of life's opportunity to appreciate each moment and each day has a contagious impact upon all around him. His love of life is reflected profoundly in this beautiful collection of photographs that allow us to ask questions without imposing answers.

Beyond this appreciation of what one can see and feel, his photographs pay as well tribute to the essential mysteries and enigma of moments of our common and individual existence.

Bravo.

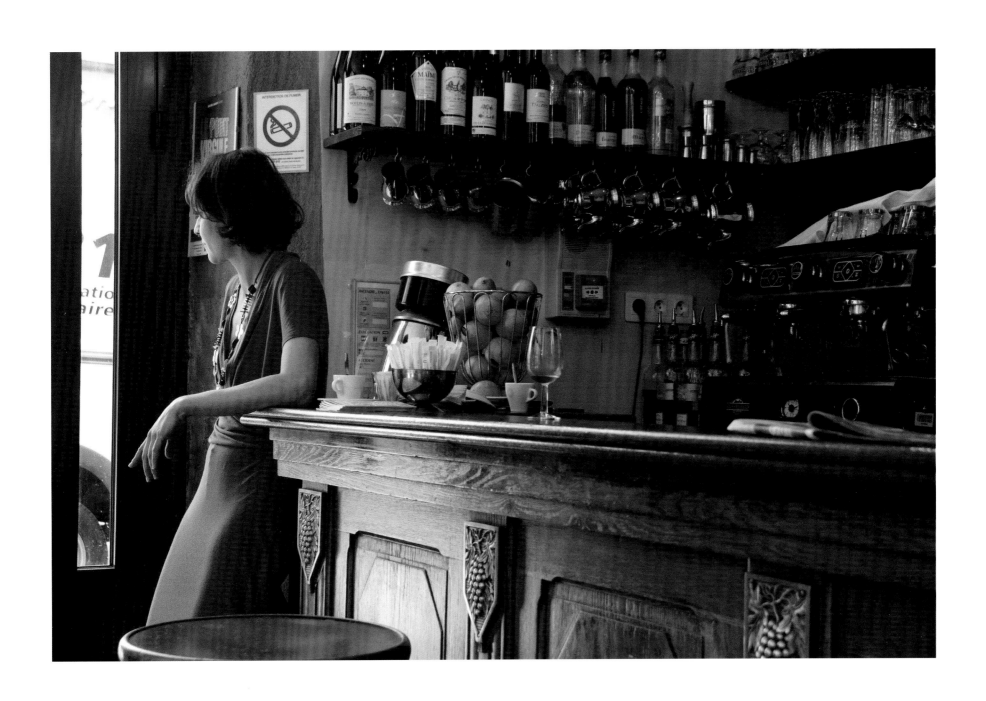

Daydreaming - Paris, France - May 2012

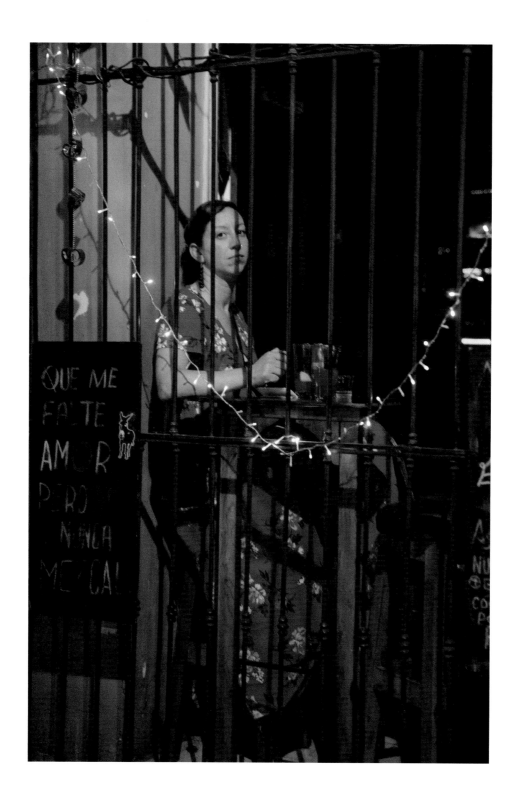

Woman in a Red Dress - Oaxaca, Mexico - March 2018

Paris Evening in the Rain - Paris, France - May 2012

Sally and I love to explore the United States. In October 2018, we decided to drive across the state of Iowa. We loved the TV show "Friday Night Lights," and I was interested in the football culture in other parts of the country. I was hopeful we might see a game in our travels. We were in Winterset, Iowa – home to "The Bridges of Madison County" – on a Friday afternoon and stopped at the visitor center.

We ended up chatting with a very nice young woman at the front desk, explaining our interest in photography. She gave us a map noting all the bridges in the county.

As an afterthought, I asked if there might be any football games in the area that night. The young woman explained that it was Winterset's Homecoming that evening. Her daughter played in the Winterset band and she was also a friend of the football coach. She would ask him if we might get access to the field. We were invited to photograph the band practice and the coach allowed us on the field to photograph the action.

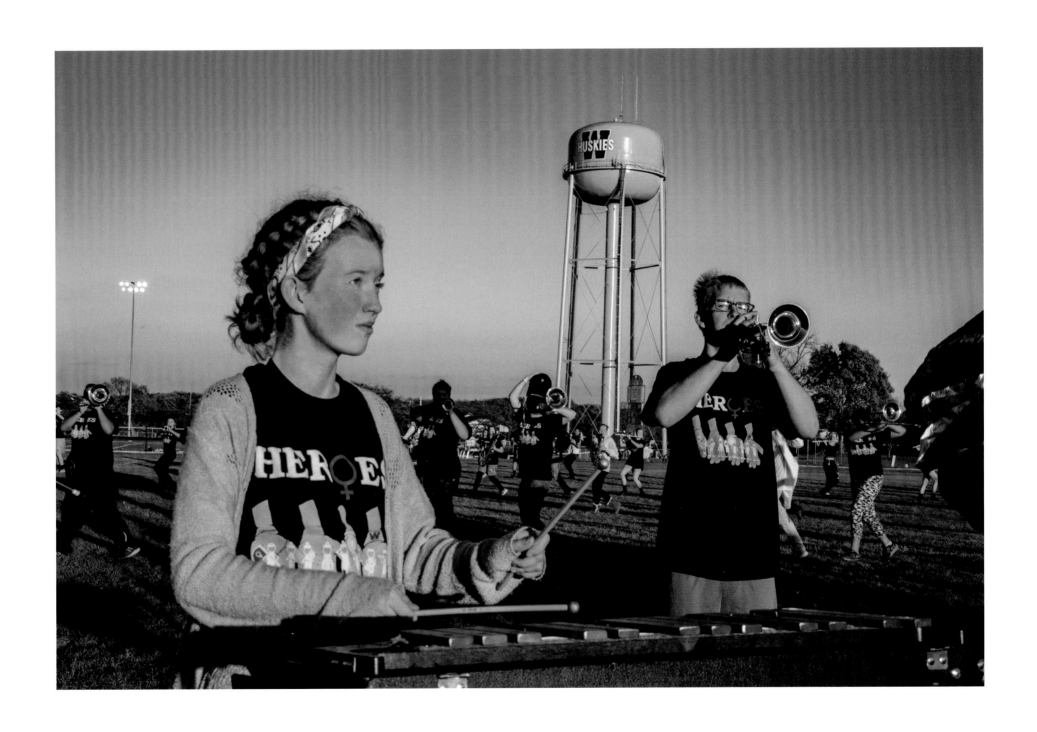

Pre-game Band Practice - Winterset, Iowa - October 2018

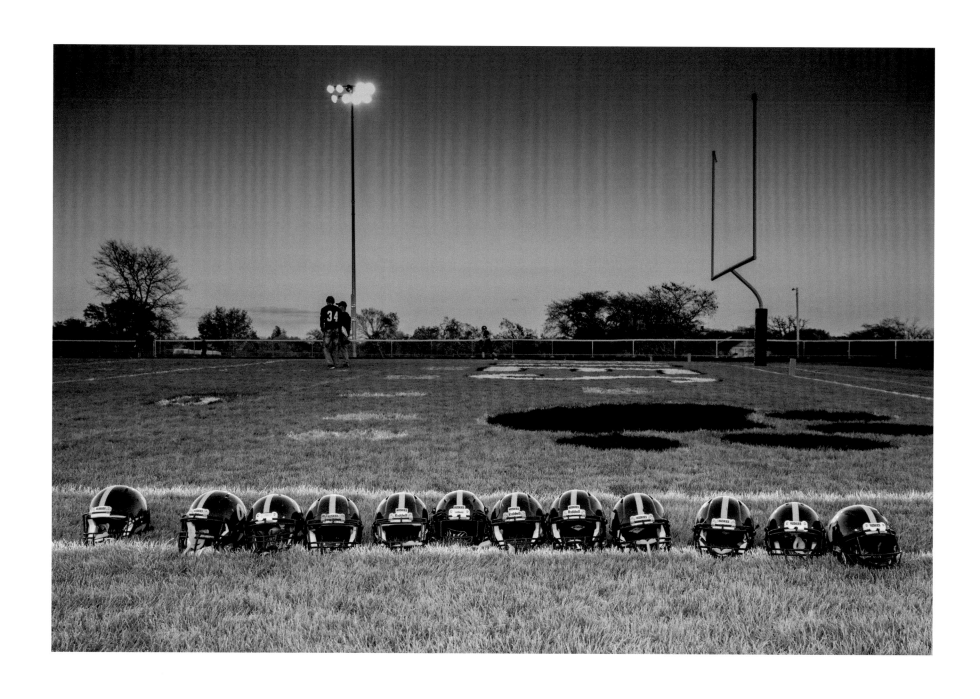

Friday Night Lights Helmet Ritual - Winterset, Iowa - October 2018

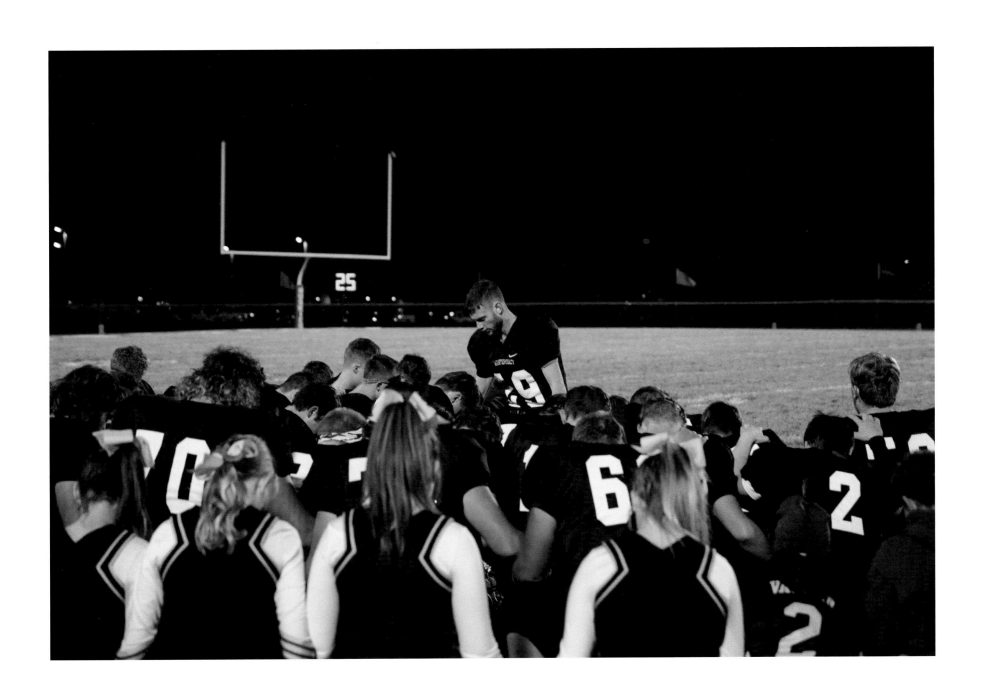

Pre-game Prayer - Winterset, Iowa - October 2018

What could be more "American" than a rodeo? From the local beauty queen entering the ring, American flag waving, to every cowboy's effort to remain atop raging, gigantic bulls.

As Sally and I researched what we might include on a multi-week road trip from Seattle into the Dakotas, I read about a rodeo taking place in the small town of Belt, Montana. We ended up planning our whole trip around this single rodeo making sure we were in central Montana that week. The town of Belt is so small there were no hotels and we had to stay in a nearby city.

For us, the smaller the rodeo the better. We liked having full access from the staging areas right up to the railings surrounding the action. At a second rodeo in Ennis, Montana, I watched shadows of two cowboys having a chat before their time to ride. Right behind them were two young boys, snow cones in hand, mimicking their heroes.

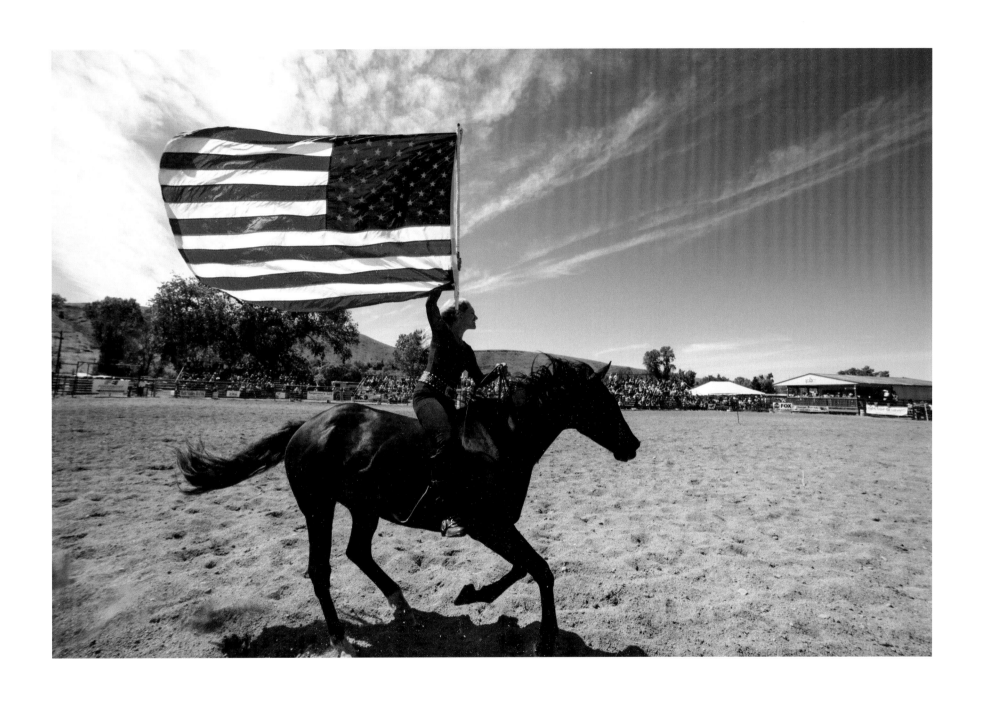

Let the Rodeo Begin - Belt, Montana - June 2016

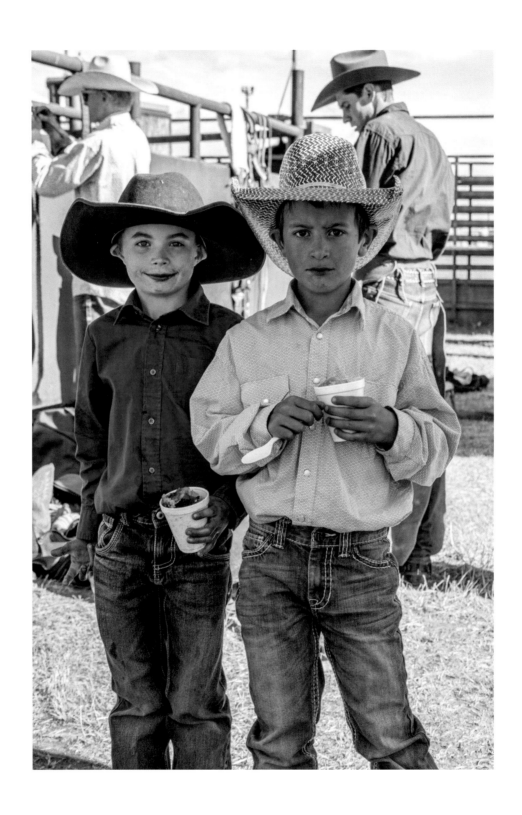

Future Cowboys of America - Ennis, Montana - July 2016

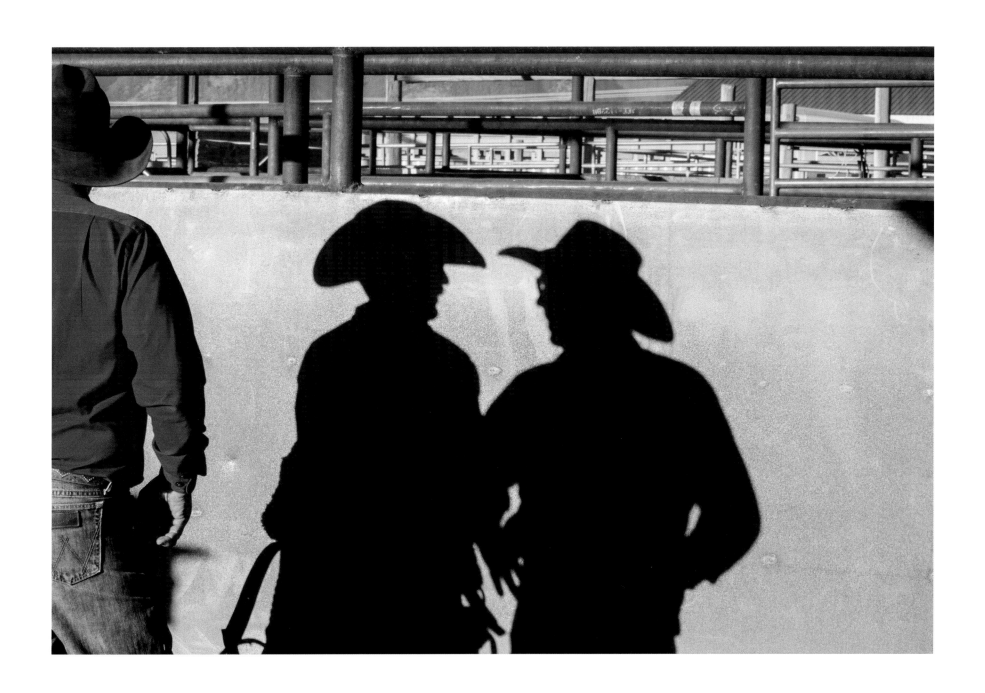

Only the Shadows Know - Ennis, Montana - July 2016

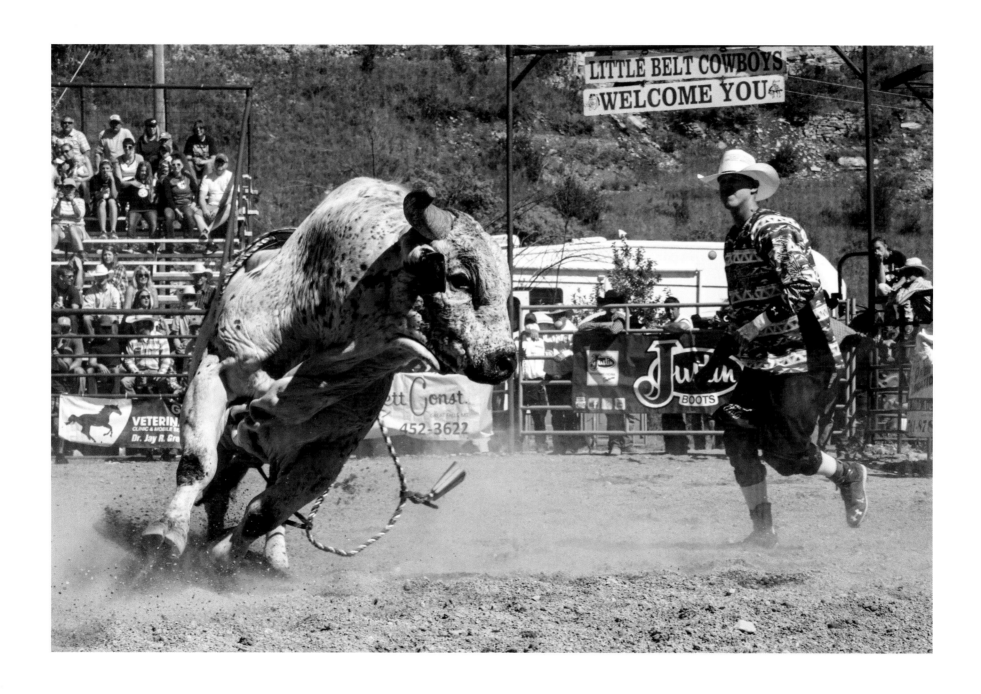

Raging Bull - Belt, Montana - June 2016

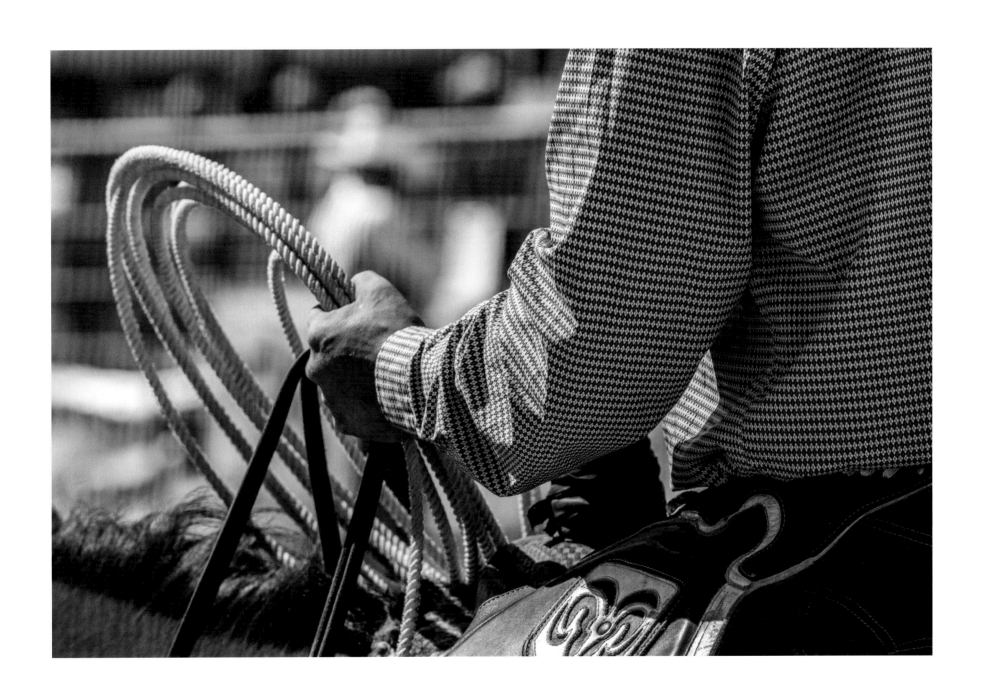

Ready to Ride - Belt, Montana - June 2016

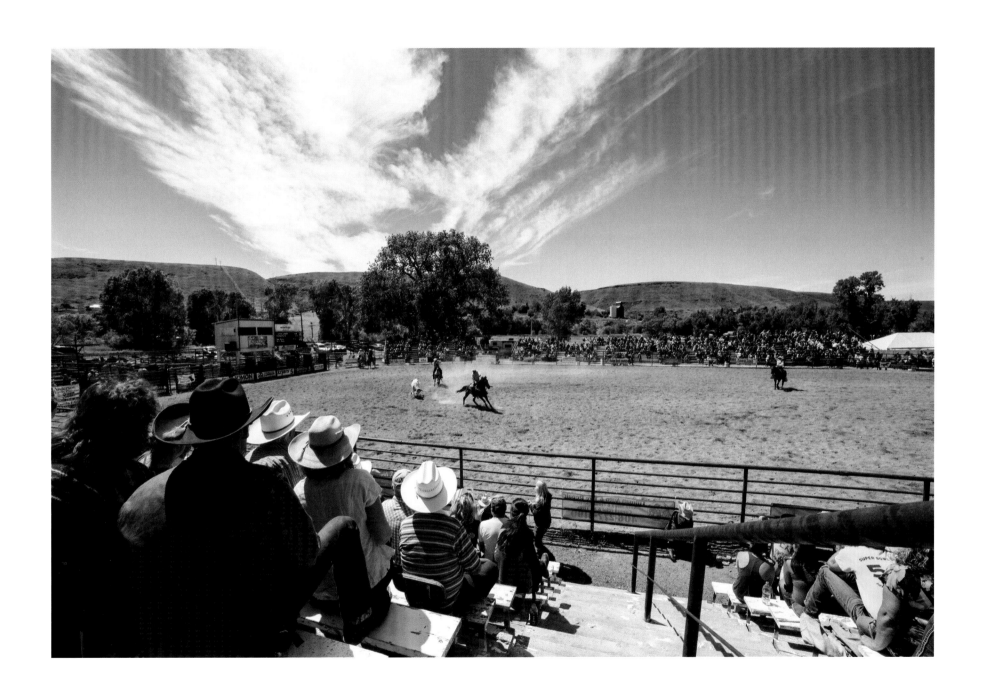

Perfect Day for a Rodeo - Belt, Montana - June 2016

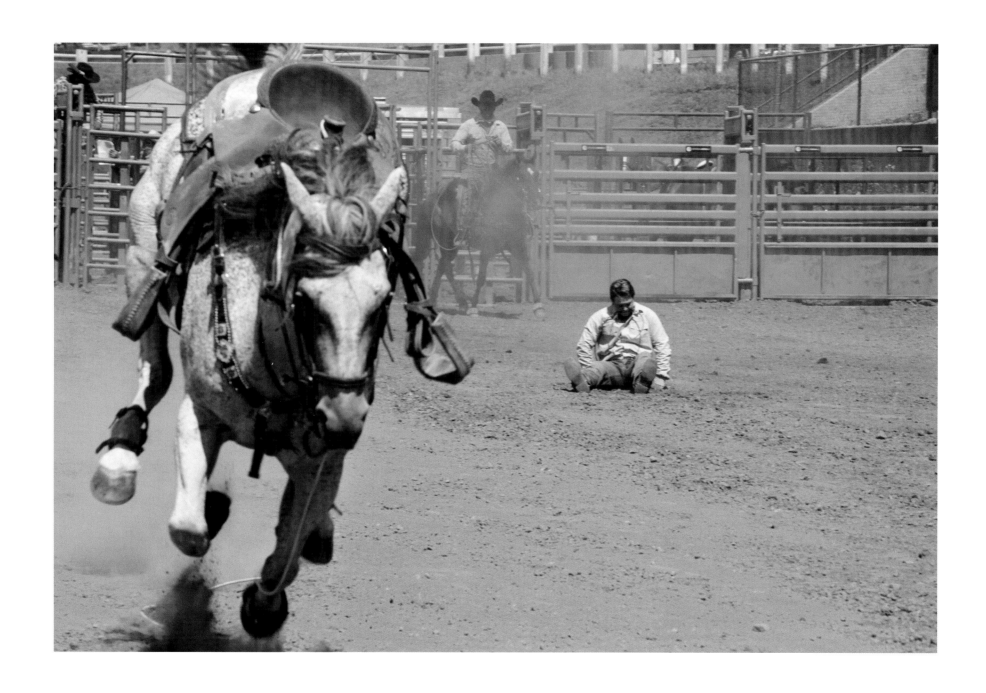

The Agony of Defeat - McHenry, Maryland - August 2015

Hats Off in the Truck - Plentywood, Montana - June 2016

Magdalena Solé, photographer
West Halifax, VT

Mike and Sally have traveled with me on two occasions to explore the Mississippi Delta, where the Old South lives on.

Mike's smile while he photographs puts his subjects at ease. He becomes a fly on the wall and moves around looking for the light, a gesture, a color to include in his frame.

This image of a man sleeping on the couch and a child running out the door has such heart and beauty. It offers a glimpse into family life in the Mississippi Delta.

The fish trophy on the wall gives a nod to the images of Eggleston. The child running past the sleeping man, surrounded by the dense yellow backdrop of the wall, expresses a unique energy and dichotomy between the exhausted man and the exuberant child.

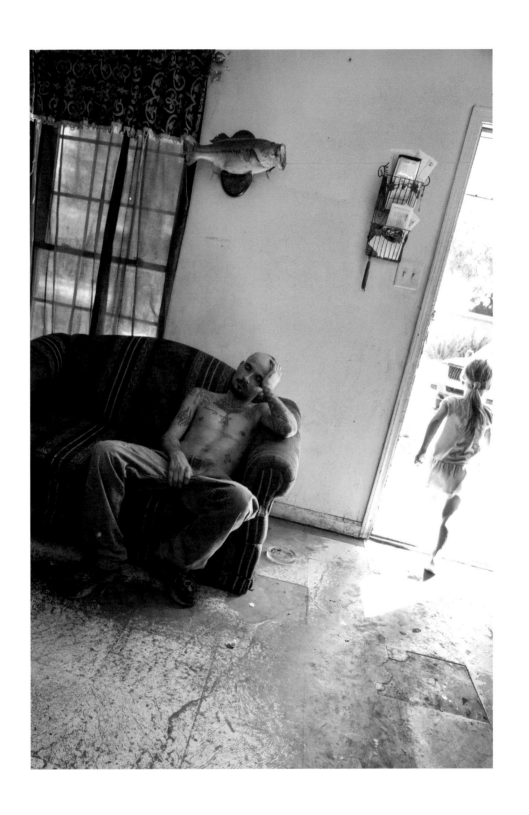

Altered State - Lambert, Mississippi - September 2019

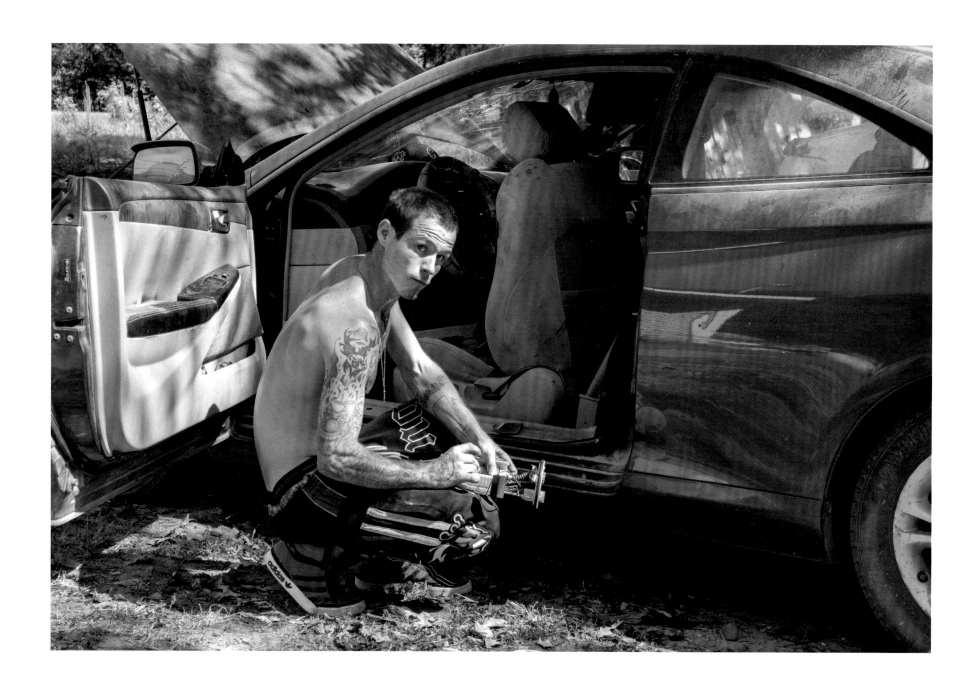

Home Mechanic - Lambert, Mississippi - September 2019

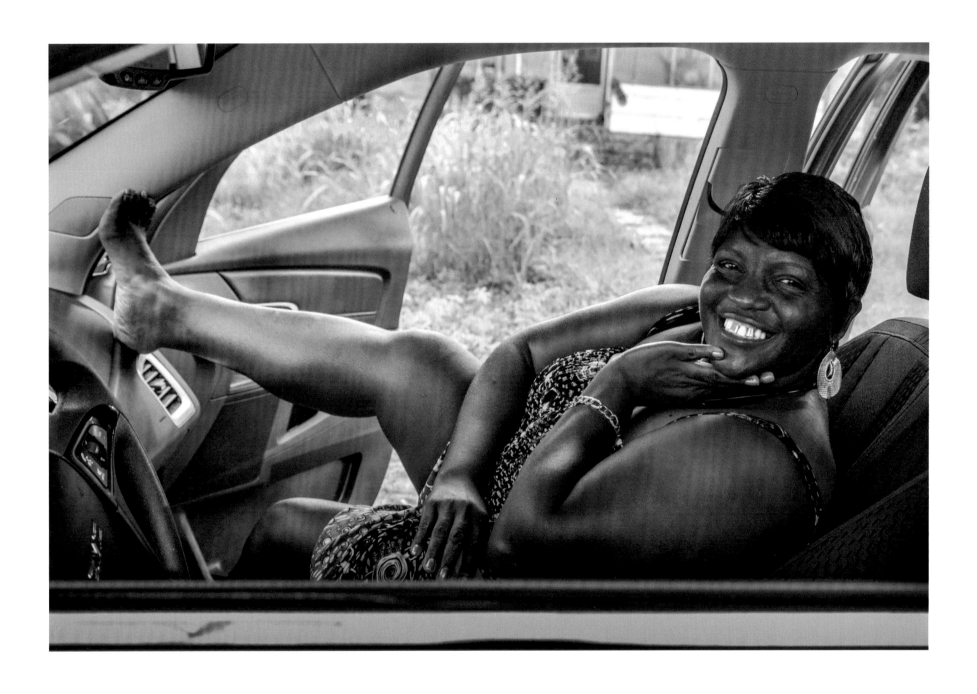

The Full Pose - Friars Point, Mississippi - September 2016

Friendly Game in a Dark Bar - Clarksdale, Mississippi - September 2016

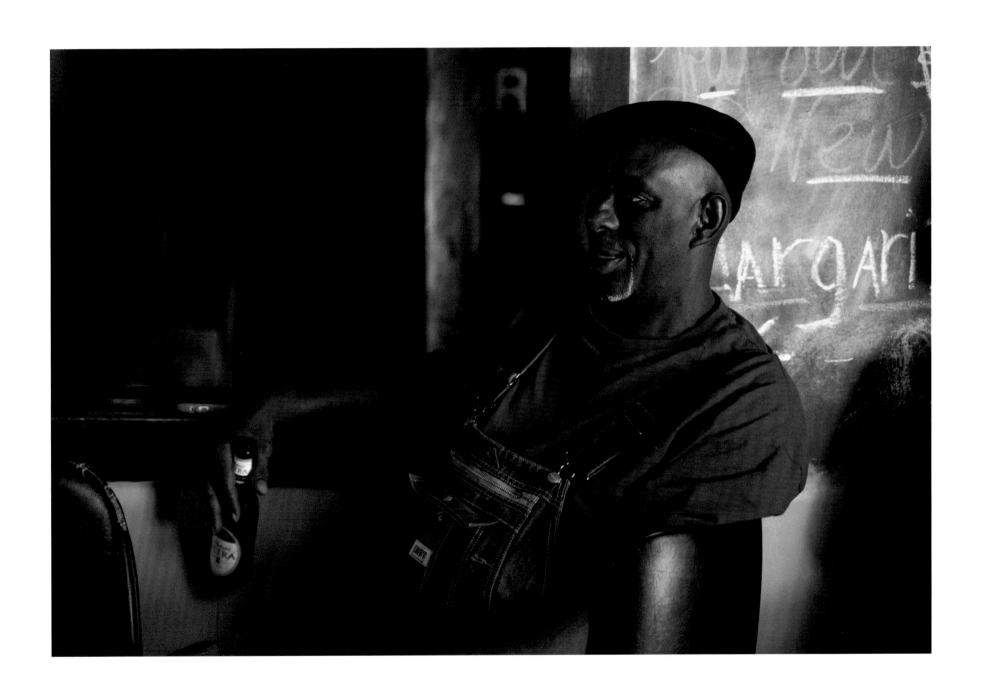

Mother-in-Law Lounge Regular - Treme, New Orleans, Louisiana - September 2016

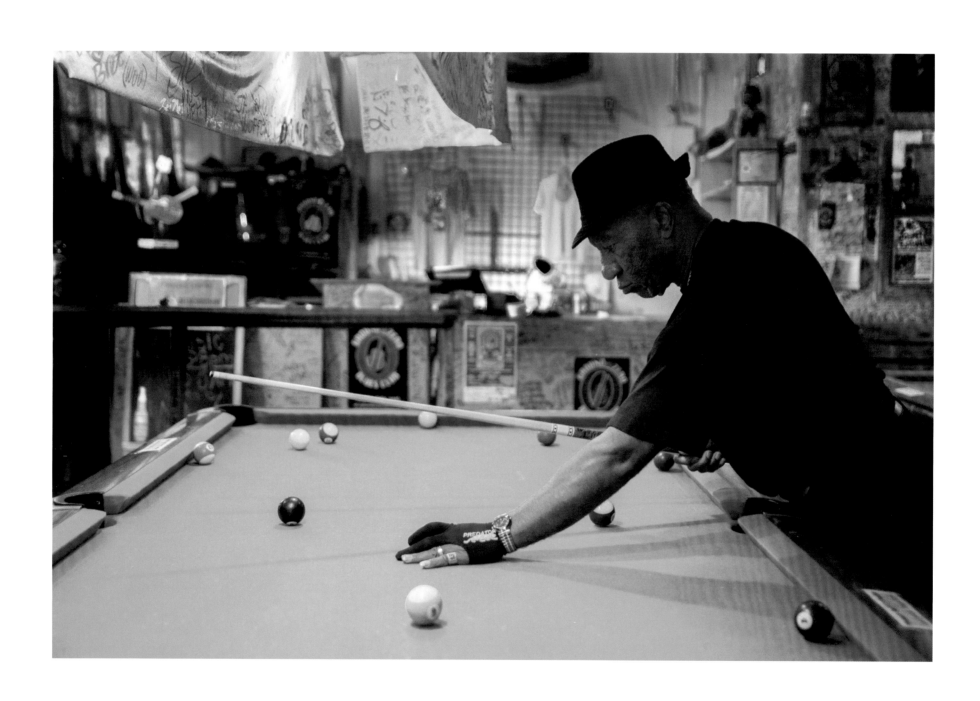

Pool Hustler Practice - Clarksdale, Mississippi - September 2019

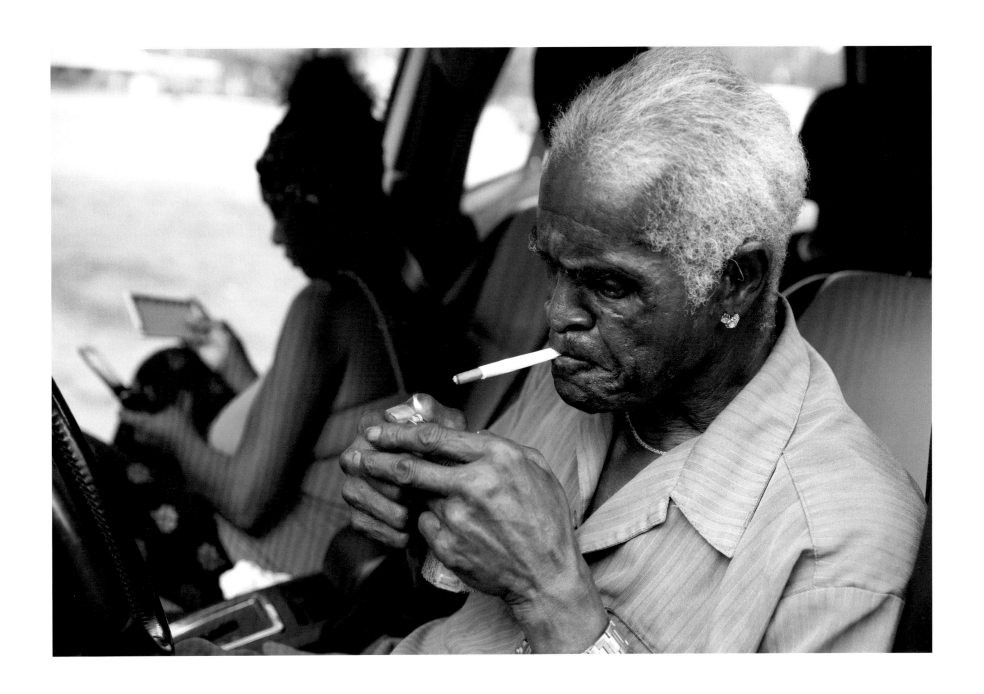

Lighting Up - Indianola, Mississippi - September 2019

We love music, and the small city of Clarksdale, Mississippi, is billed as the "Birthplace of the Blues." The city is about an hour south of Memphis and just east of the Mississippi River. The flat area of land running about 200 miles along the river from Tunica south to Vicksburg is known as the Mississippi Delta.

We rolled into town on a Saturday night and headed straight to Ground Zero Blues Club for our first taste of live music. There we met Razorblade. He was obviously a colorful character, and I approached him after his performance to chat. Razorblade immediately asked if I wanted to buy his CD. "Absolutely," I responded, "but I also would like to take some photographs of you." Agreed. Sally, Razorblade and I sat on the porch outside and had a great talk. We learned that Razorblade's real name was Joshua Stewart, but people called him Razorblade because "I dress so sharp." After sharing his interesting philosophy of life, the subject turned to religion. We asked about his church and whether visitors were welcome. With that, Razorblade invited us to attend Union Grove Baptist Church the next morning as his guest. We accepted enthusiastically.

We sat near the front of the packed church, standing out as the only non-African Americans. A line of well-wishers came up before the service to warmly welcome us to their community. While we chose not to take photographs, we will never forget the service: the sermon, the music, the joy of celebrating God.

Four years later, I wrote a story about our experience for our local newspaper. While fact-checking for proper names, I came upon the Facebook site for Union Grove. The first post on that day reported that Razorblade had died several days before, on April 21, 2018, and the congregation would be celebrating his life. The obituary reported that Josh (Razorblade) Stewart was 72. I could have sworn he was close to 90. This simply illustrated for me the hard life our friend must have led.

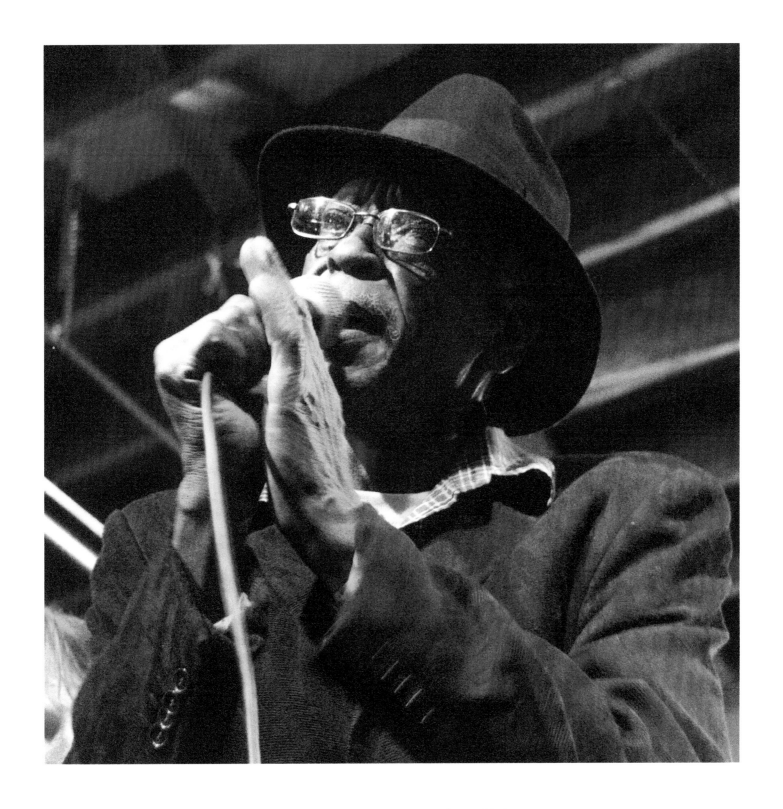

Razorblade - Clarksdale, Mississippi - June 2014

The Presence of God - Greenwood, Mississippi - September 2016

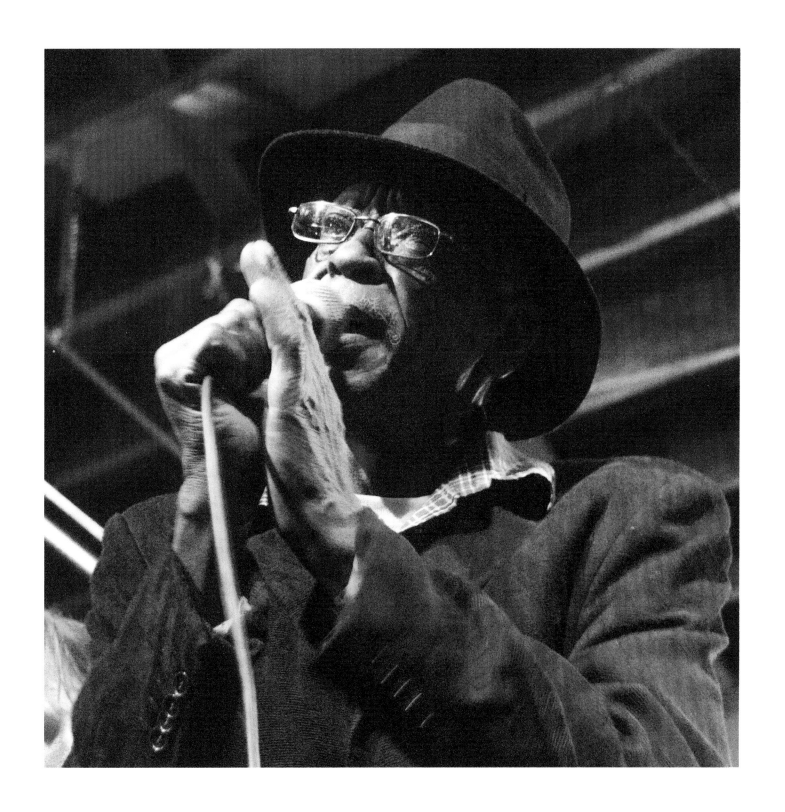

Razorblade - Clarksdale, Mississippi - June 2014

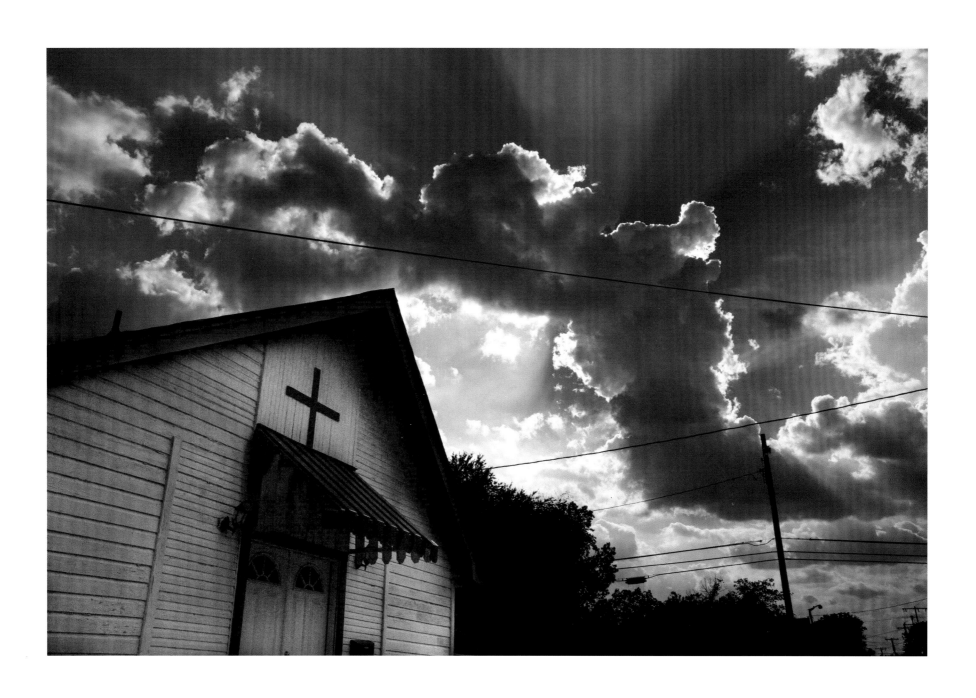

The Presence of God - Greenwood, Mississippi - September 2016

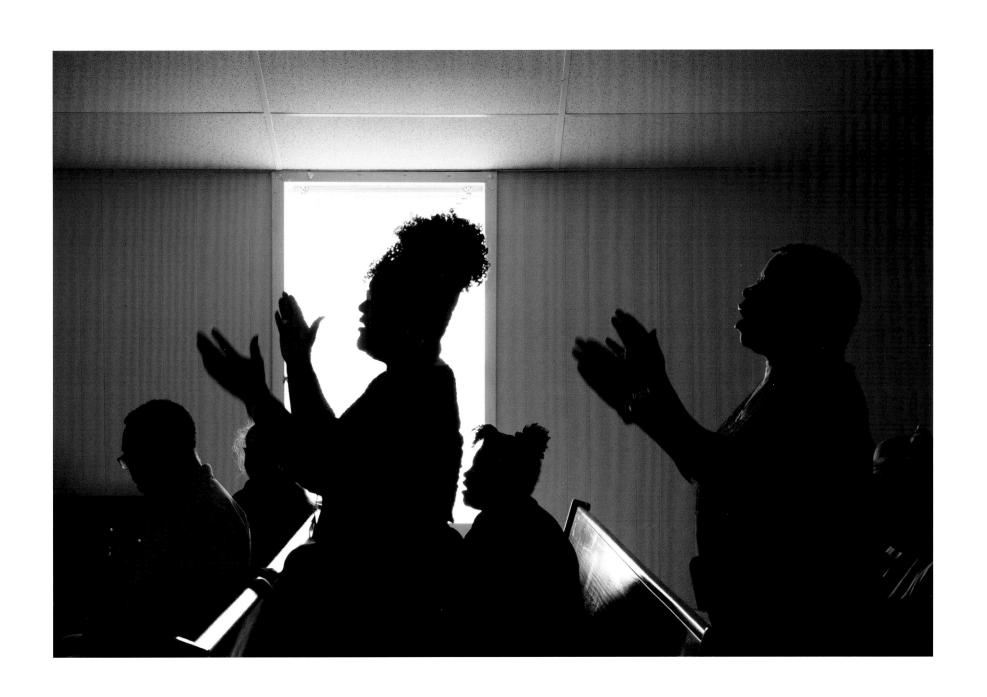

Praise the Almighty - Jonestown, Mississippi - September 2019

Sally and I have had the good fortune to travel extensively to foreign countries and across the United States. But one of the best places to photograph is just an hour's train ride away from home. There is always something happening in New York City.

Sundays at Coney Island teem with life. There is swimming, enjoying the carnival rides or just strolling the Boardwalk. A group of amateur gymnasts meets at the beach each Sunday morning to show off their talents, as pictured on the opposite page.

The following pages feature photos of screaming riders at Coney Island; a walk among the crowds on the Highline, a unique Manhattan park built on an old railroad trestle; a night game at Shea Stadium, and a young boy, arms outstretched, running through a downtown Manhattan playground fountain.

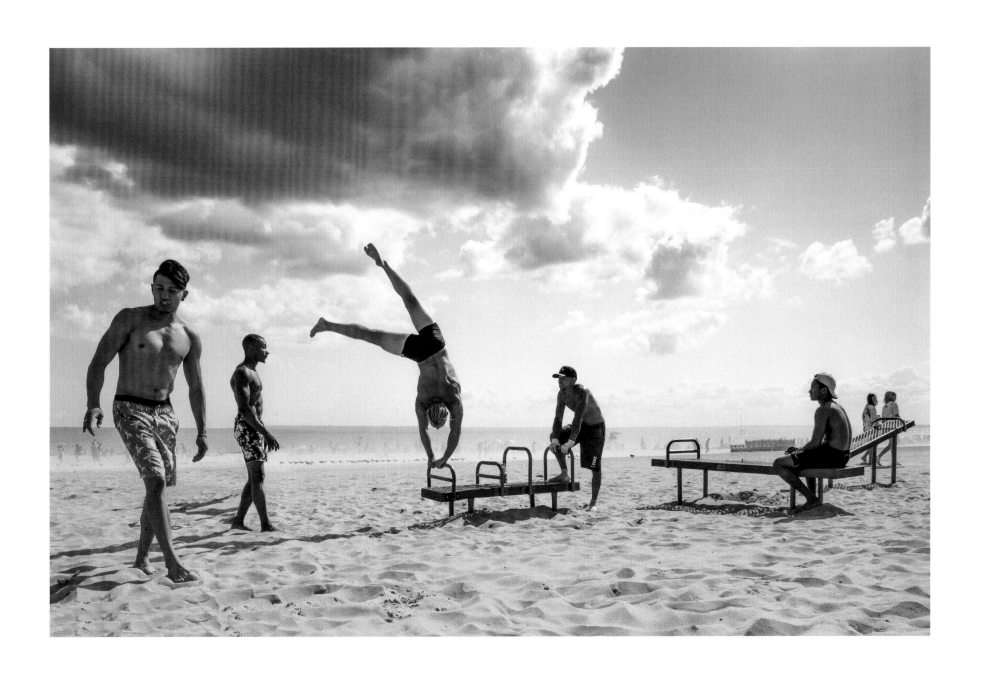

Beach Gymnastics - Coney Island, New York - August 2019

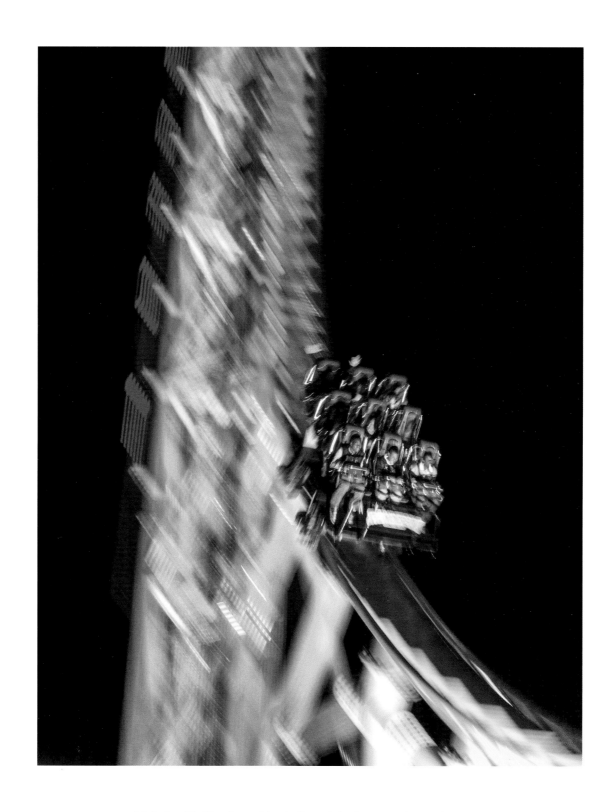

Nighttime Thrill at Coney Island - Coney Island, New York - October 2014

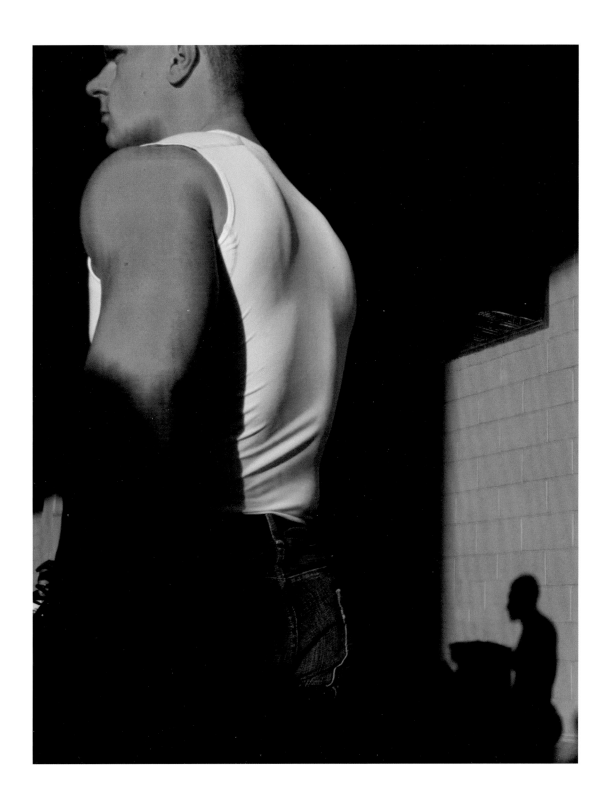

Highline Hunk and His Tiny Shadow - New York, New York - October 2011

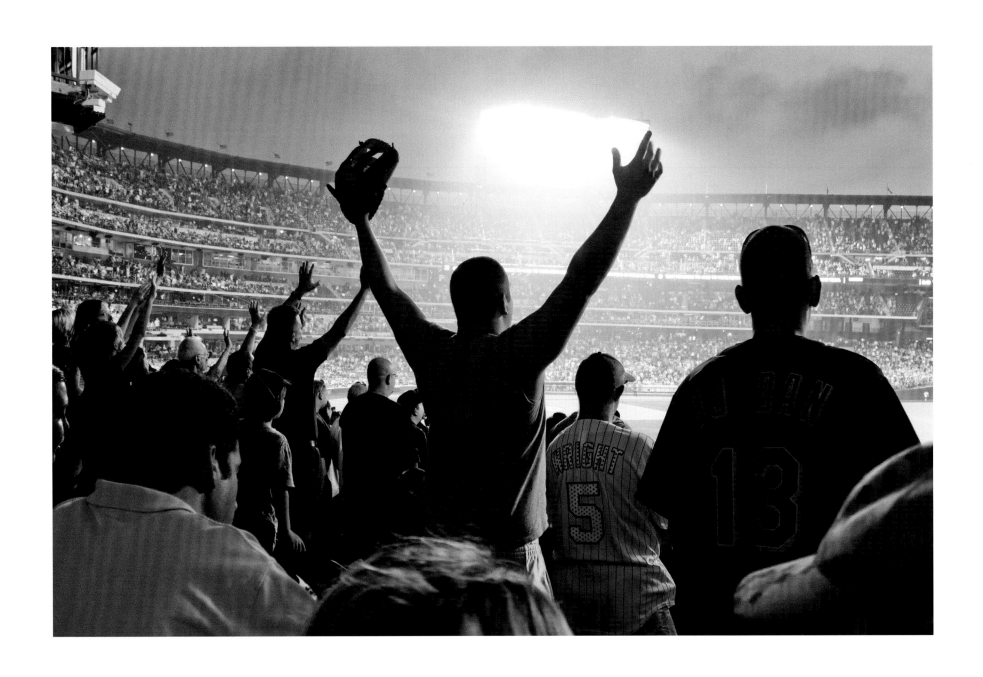

Going, Going, Gone! - Queens, New York - July 2011

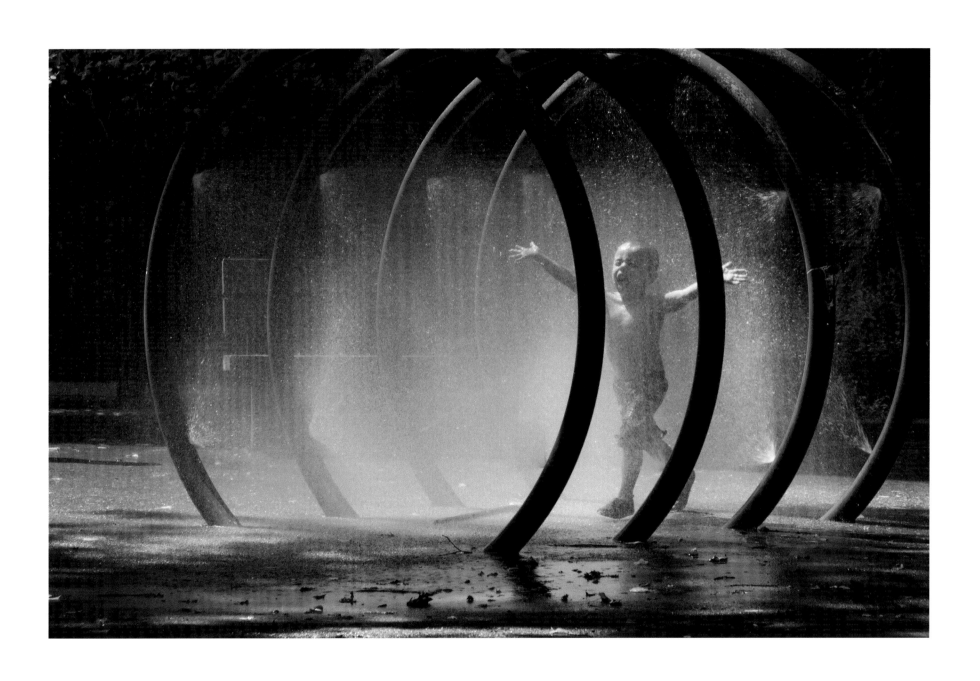

Summertime Joy - New York, New York - July 2013

Risqué Business - Oaxaca, Mexico - March 2018

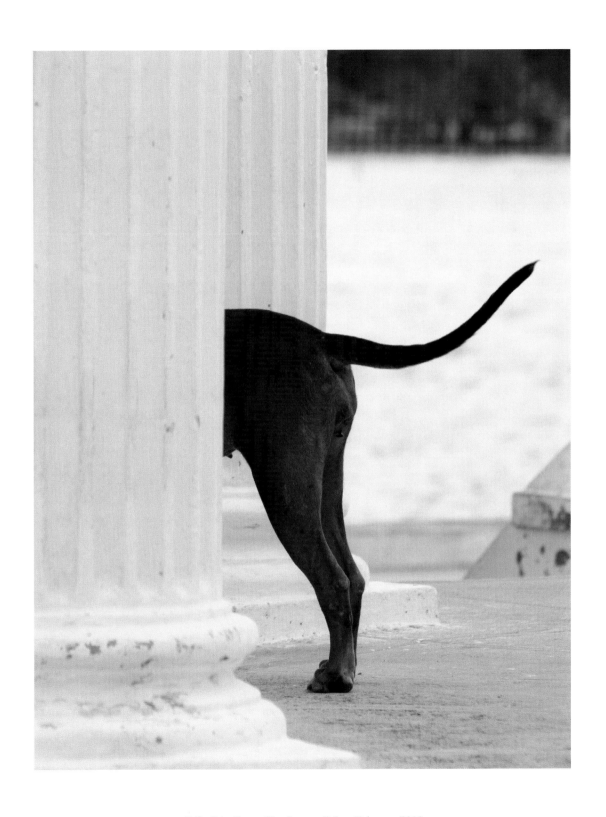

Tail of the Dog - Cienfuegos, Cuba - February 2012

Icelandic Horse Crosses the Horizon - Skagafjörour, Iceland - June 2015

When you drive through an Amish area, it can seem as if you have entered a foreign country, right here in rural America. Horse-drawn buggies replace roaring car engines. Self-invented games replace the iPad. Reading a new book replaces the latest TV show. I admire and respect, even envy, how peace and serenity replace the rush and chaos of our world.

My family has a vacation home in northwest Maryland, just below the Pennsylvania state line. Sally and I headed out on a beautiful June day in 2015, cameras in hand, to explore Springs, Pennsylvania. Springs is known for its rolling hills and the number of Amish families who live there. The Amish are known for their unwillingness to be photographed, and my expectations were low.

We passed a roadside stand called Yoder's. Seeing that the boys tending the store were wearing straw hats and suspenders, we pulled over and went inside. After introducing ourselves and buying some baked goods, I asked if it would be okay if we took some pictures, and they said it would be alright.

A couple of months later we stopped by the stand with prints of the photos from our first visit and asked the children to share them with their parents. Upon returning home we hand-wrote a letter addressed to Mr. and Mrs. Yoder, Roadside Stand, Springs, Pennsylvania. The letter introduced Sally and me and made the point of how much we respected the Amish way of life. We said we would like to meet them and the other children. Last, we made the point that we would like to photograph the family and their way of life.

Within a couple of weeks, we received a three-page response from Saloma Yoder. The letter introduced us to Saloma and Pete and each of their ten children (now thirteen). The letter welcomed us to come to their home. This thoughtful response was the beginning of a long and valued friendship.

The Amish in the area are not permitted to have a telephone in their home, as it would disrupt the peaceful nature of their life. There is a telephone booth in a nearby field, shared with neighbors, and the Yoder children regularly check for messages. We were given the number to call and leave a message as to when we might arrive.

When we arrived for our scheduled visit, Saloma, Pete and all ten children were standing outside their home to greet us. I knew in my heart that I would always remember the vision of these twelve beautiful people at that moment, pictured on the opposite page.

The photographs that follow were taken during many separate visits with the family over a period of five years first in Pennsylvania and later in their new home in Bennington, Indiana. We now feel like family members and look forward to gathering with the Yoders and chronicling each member for years to come.

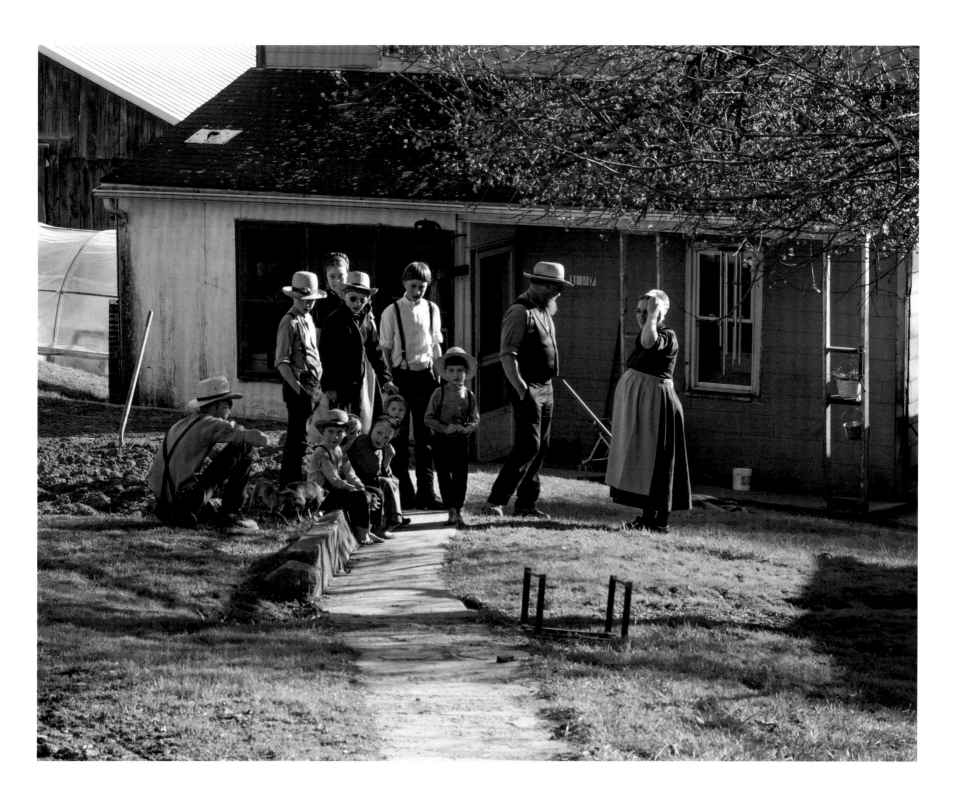

The Yoders - Springs, Pennselvania - April 2016

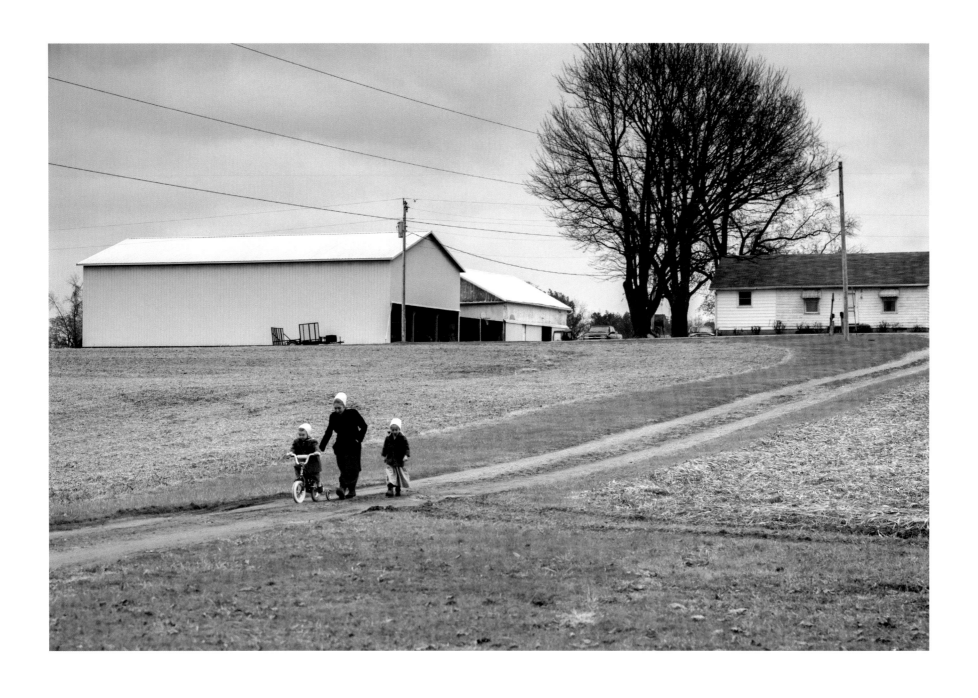

Fun Along the Driveway - Bennington, Indiana - November 2017

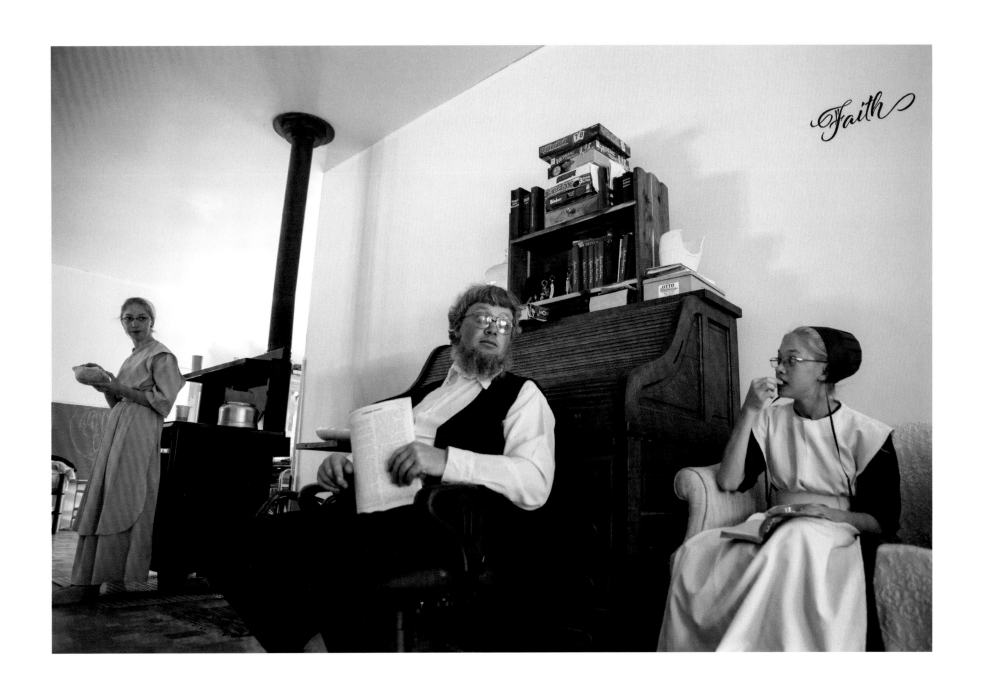

Faith - Bennington, Indiana - October 2019

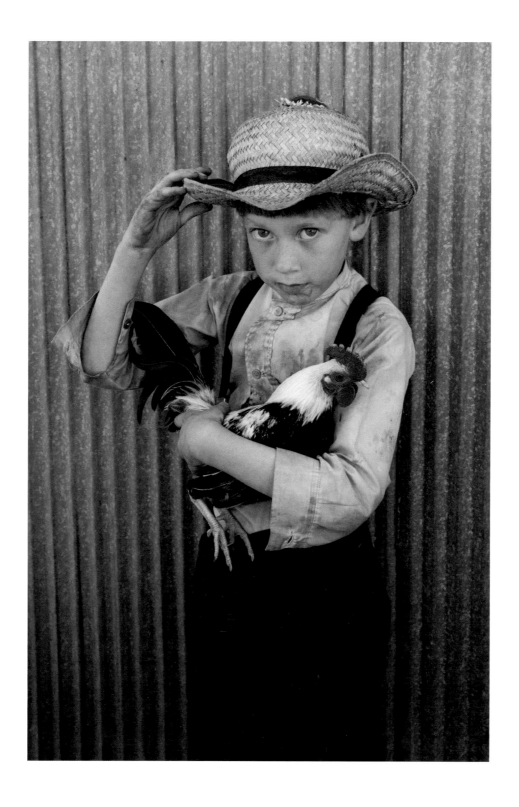

Daniel Holds His Rooster - Springs, Pennsylvania - April 2016

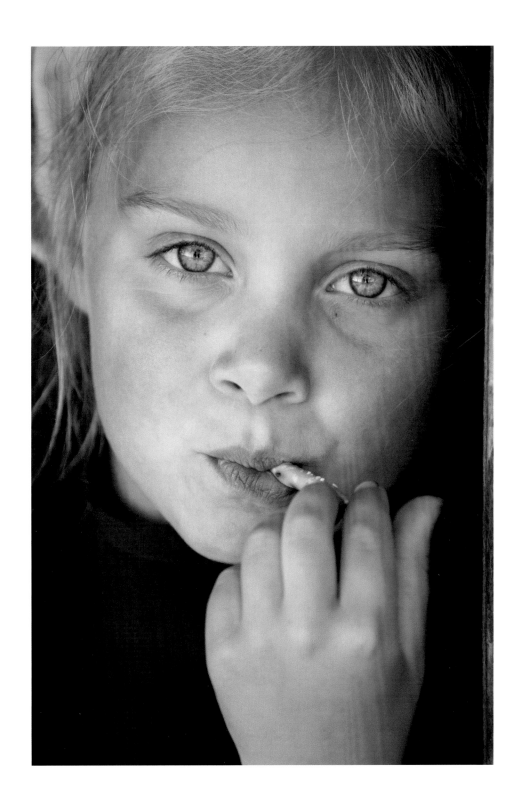

Tillie and Her Pretzel - Springs, Pennsylvania - June 2015

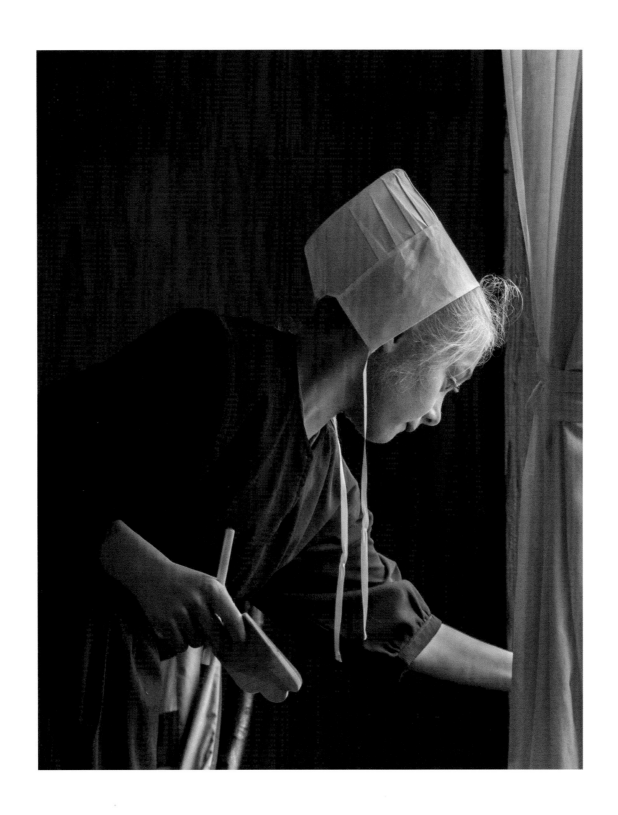

Ruth at the Window - Bennington, Indiana - November 2017

Just Hanging Out - Bennington, Indiana - November 2017

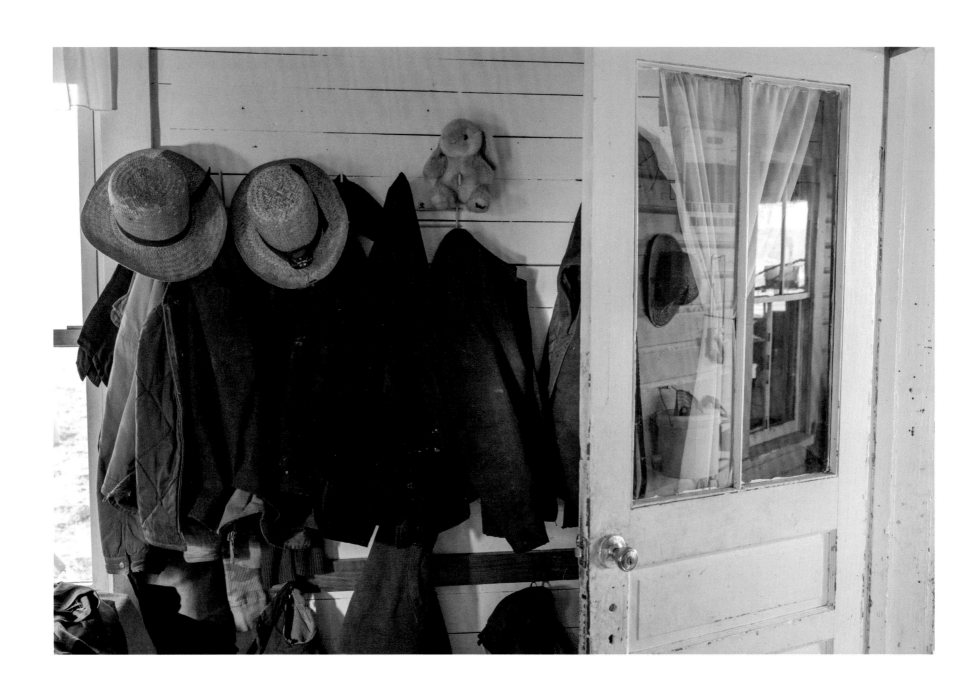

Three Hats and a Bunny - Springs, Pennsylvania - April 2016

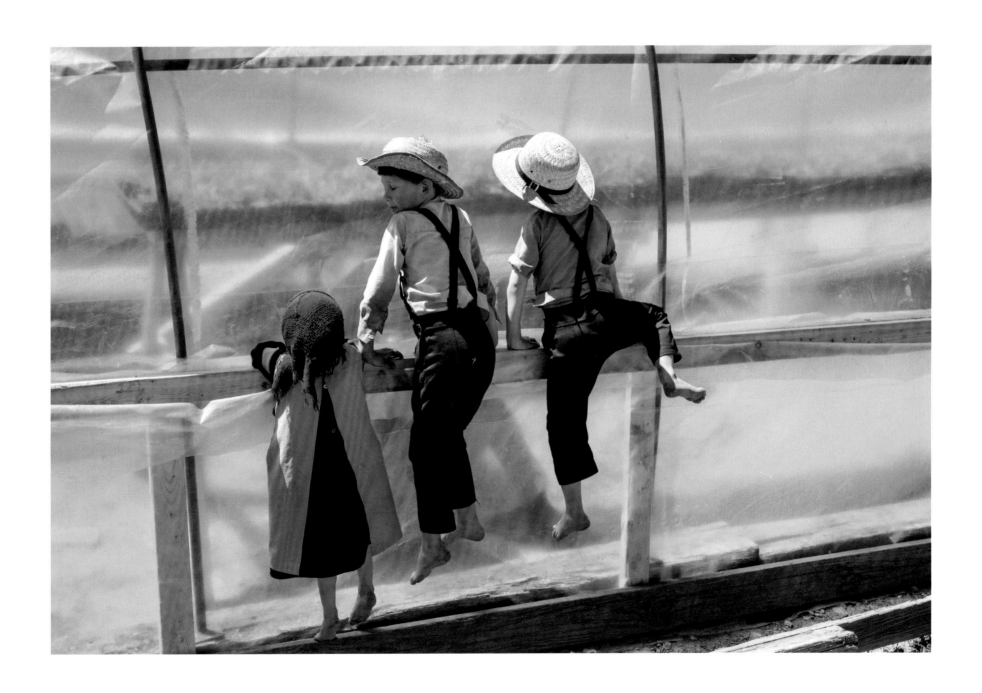

Three Yoder Siblings Climbing on Greenhouse - Springs, Pennsylvania - April 2016

Saloma Yoder's parents are Enos and Olive Bender. They were in their early 70s when we first met and lived in a separate home on the adjoining property. Olive told me she and Enos had sixty-six grandchildren.

Unlike Saloma and Pete and their children, neither Olive nor Enos was comfortable with being the subject of a portrait, but they did not mind being photographed doing chores.

Olive and Enos use a horse and buggy when they need to go somewhere. Upon arriving at the Yoders for a visit in May 2016, I was surprised when Enos asked if it would be possible for me to drive him into town to deliver a bag of walnuts at the local farmer's exchange. It felt strange, me driving Enos six miles to nearby Grantsville in our Lexus SUV. Enos never owned a TV, yet there he was in front of the GPS screen. But it did not seem to trouble Enos one bit. When we returned, he asked how much he owed me. I told him "Not a thing. That is what friends are for."

I asked Saloma if we might attend church with the family. She explained that there is more demand than the church can accommodate. They can attend only every other week, and this was an off week for their family. She went on to explain that the service lasts three hours and is in German. At that point, I felt a little relieved that it was their "off" week.

Saloma asked her dad to show us the church. Enos agreed and off we went in the Lexus. When we arrived, Enos first showed us the barn that sits parallel to the church. When members arrive for worship, they dismount from their buggies and take the horses into the barn stalls for protection from bad weather. Enos then unlocked the doors to the church. He also took the time to walk around outside, opening the shutters on the large windows. The light came streaming in, and I made this photograph of Enos after he re-entered through the rear door.

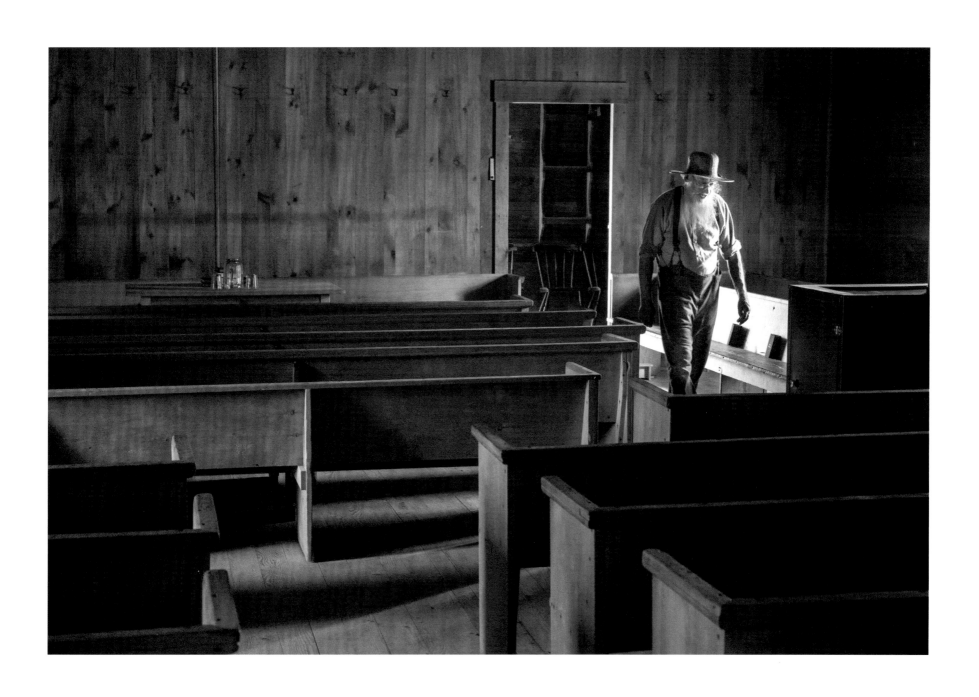

Enos Bender at the Church - Springs, Pennsylvania - May 2016

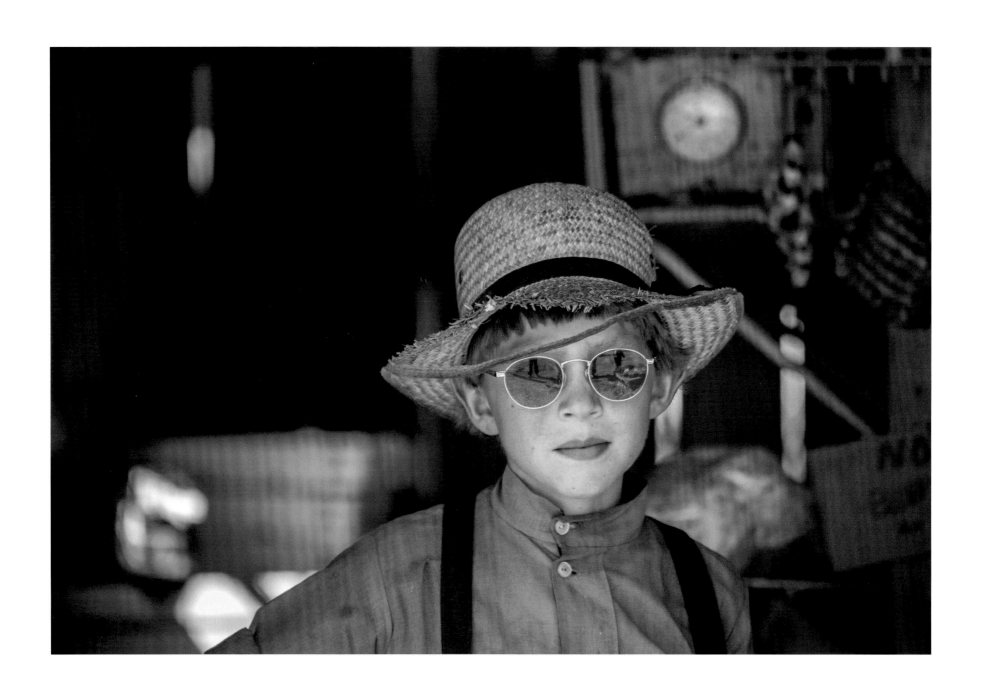

Portrait of Harvey - Springs, Pennsylvania - June 2015

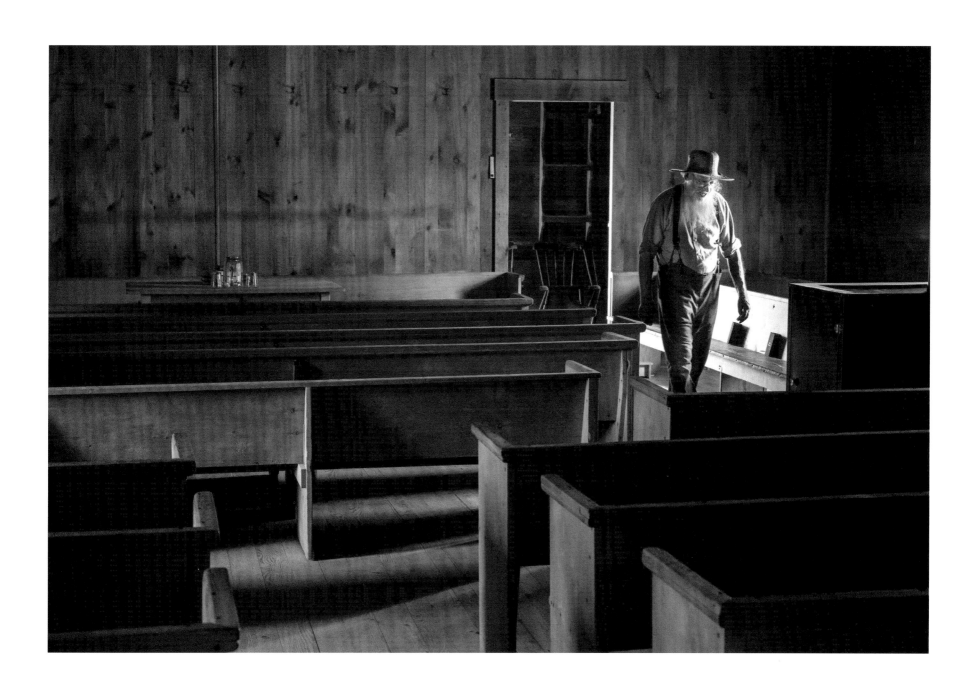

Enos Bender at the Church - Springs, Pennsylvania - May 2016

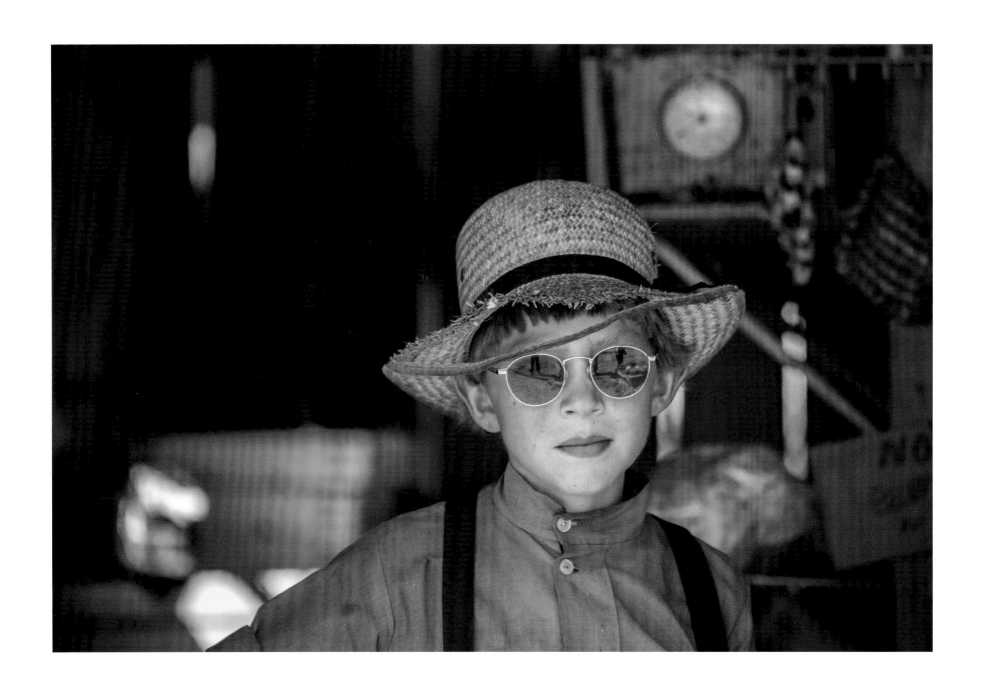

Portrait of Harvey - Springs, Pennsylvania - June 2015

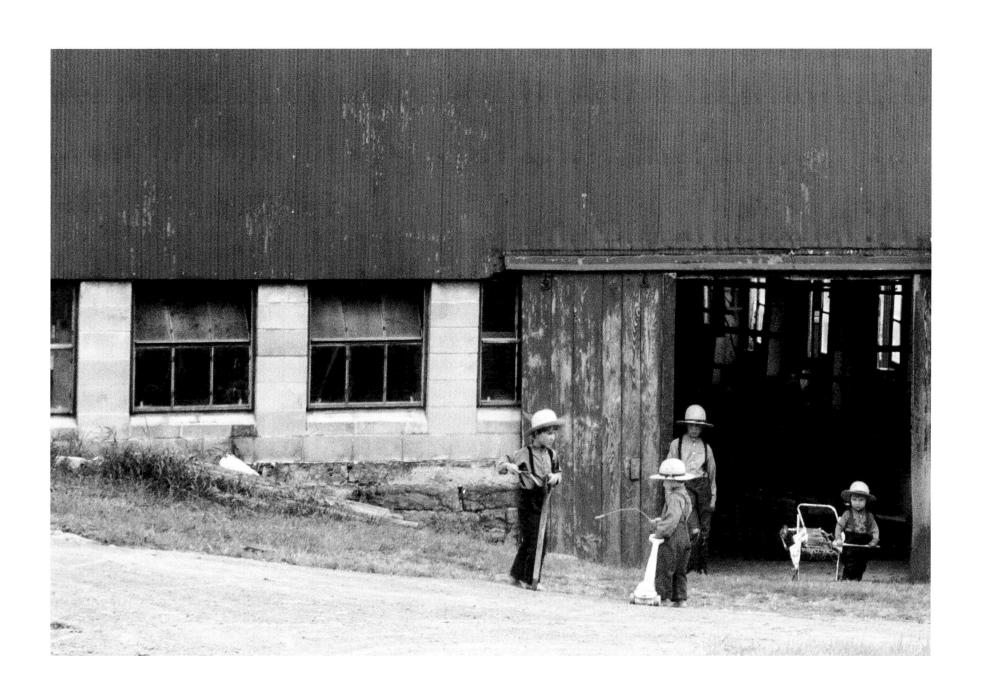

Kids' Play at the Barn - Springs, Pennsylvania - August 2015

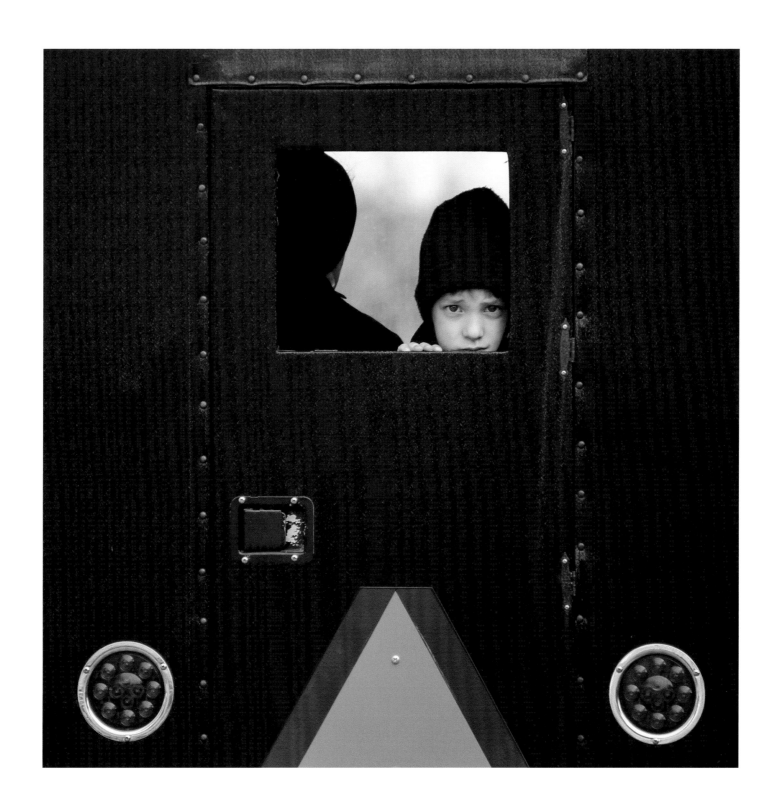

Rear View from the Buggy - Wilmot, Ohio - November 2015

Hutterites make up a religious minority who, like Mennonites and the Amish, trace their roots to the Radical Reformation. They differ in their way of life, however, by living communally. You will find many Hutterite communities scattered in the northern plains of the US and throughout Western Canada.

There is typically a community business, often related to farming. All male members of the community work in the business, and the females do stereotypical women's chores. The profits of the business are shared in a way that allows all community members to live the same lifestyle.

On a single trip through the Northwest, we visited four Hutterite communities. Calling ahead about a visit, we were always well-received and taken on a tour. We generally had permission to photograph with discretion, although one community did not permit photographing people.

Our third visit was to the Prairie Elk Community near Wolf Point, Montana. Our tour included a stop in a brand-new apartment complex. Five young women in their modest patterned blouses and matching hand-sewn dresses were spackling the walls. They stopped their work and with our permission sang three beautiful a cappella hymns. Their photo appears below.

As we chatted after their singing, one girl asked, "Why Canon, and not Nikon?" This question puzzled me. It is a question normally asked by one photographer to another. I had not thought of Hutterites as being photographers, but this girl certainly was. She left for a moment and returned with her Nikon camera to share some of her photos. They were beautiful scenic shots. At that point I asked if I might take her photograph. She agreed and the photo on the facing page is the result.

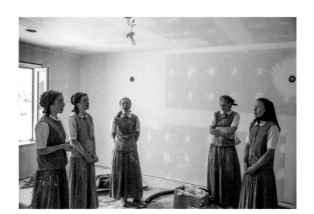

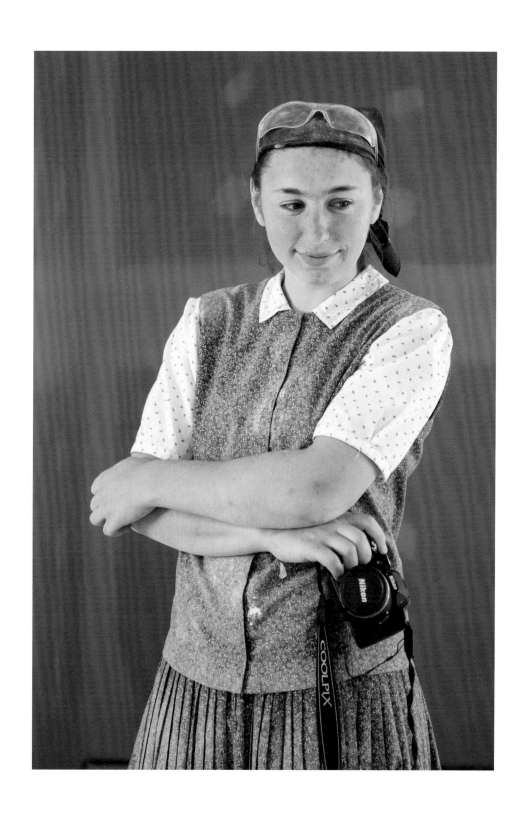

Hutterite Girl with Her Nikon - Wolf Point, Montana - June 2016

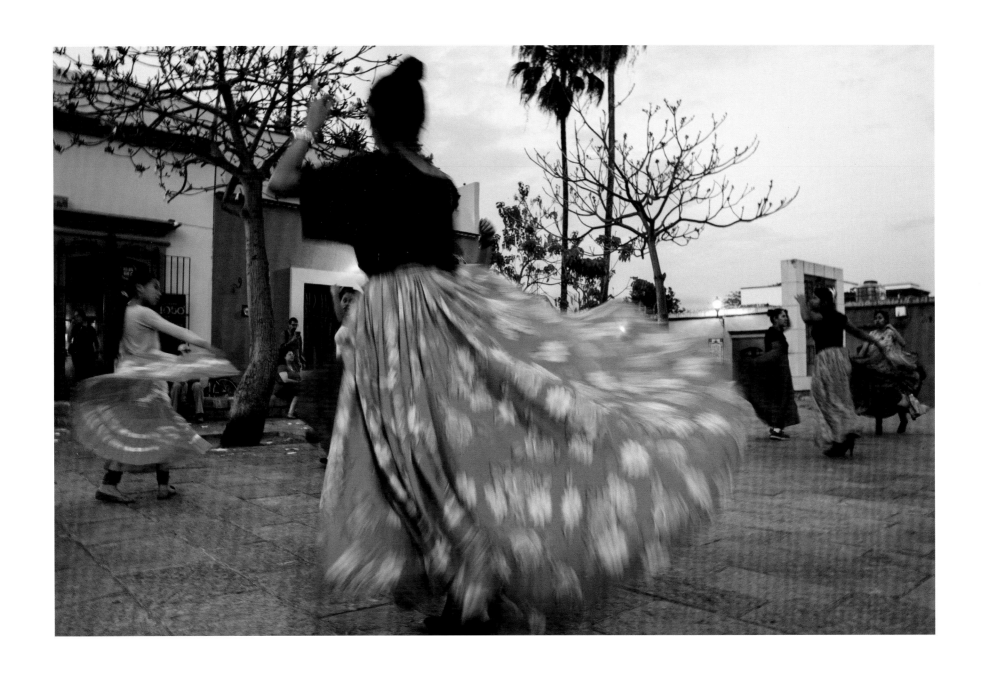

Dance Practice on the Plaza - Oaxaca, Mexico - March 2018

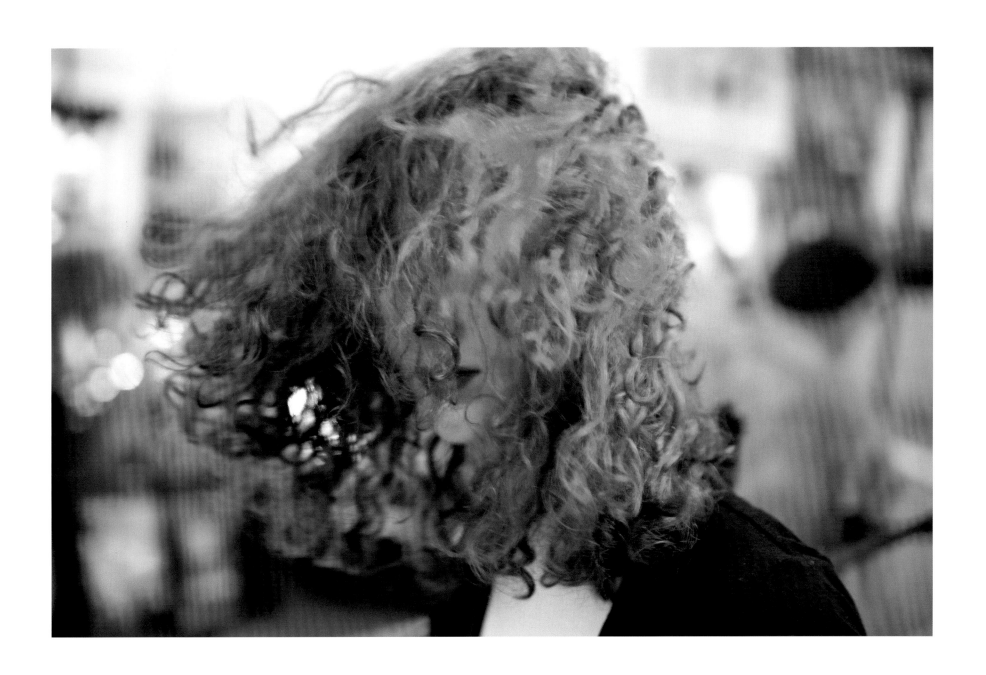

Red Head and a Gust of Wind - Greenwich, Connecticut - May 2018

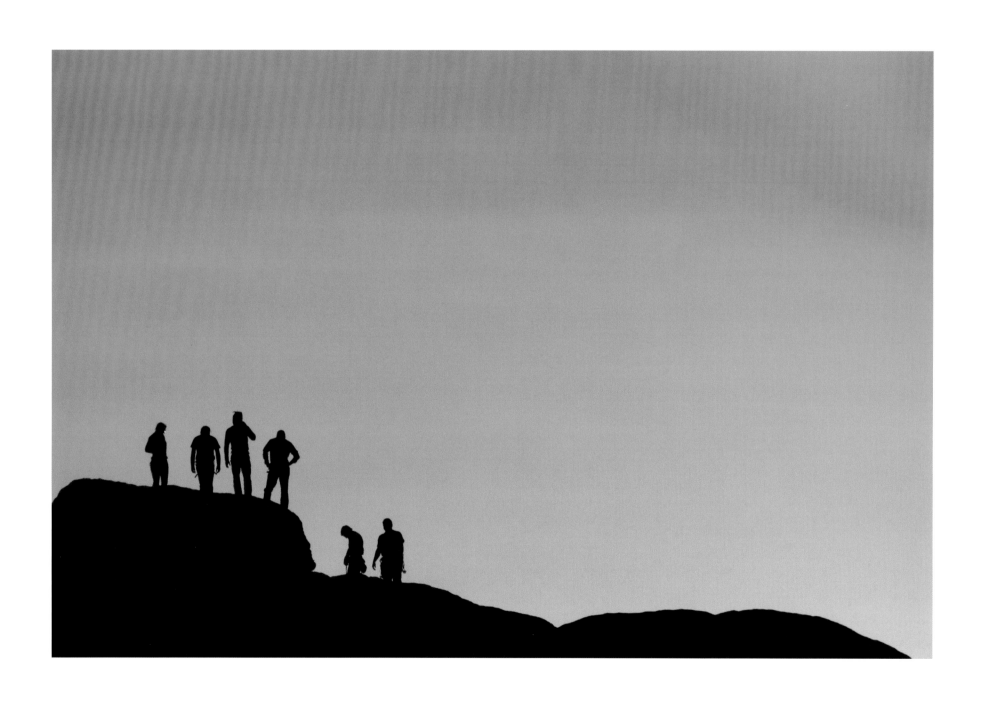

Rock Running - Joshua Tree National Park, California - January 2014

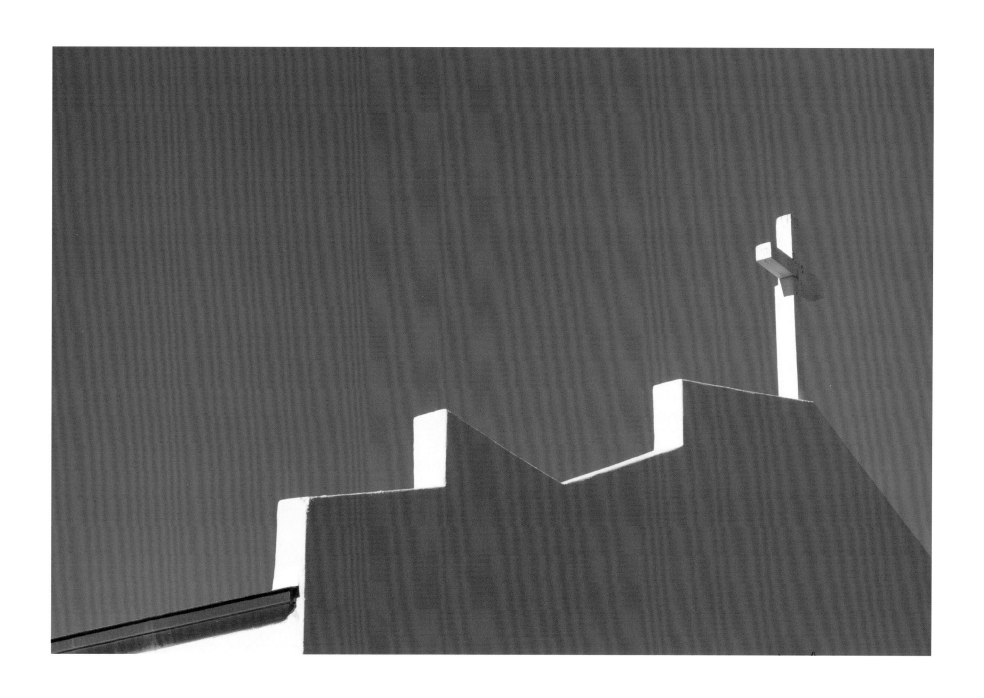

Catholic Mission Roof Line - Borrego Springs, California - January 2014

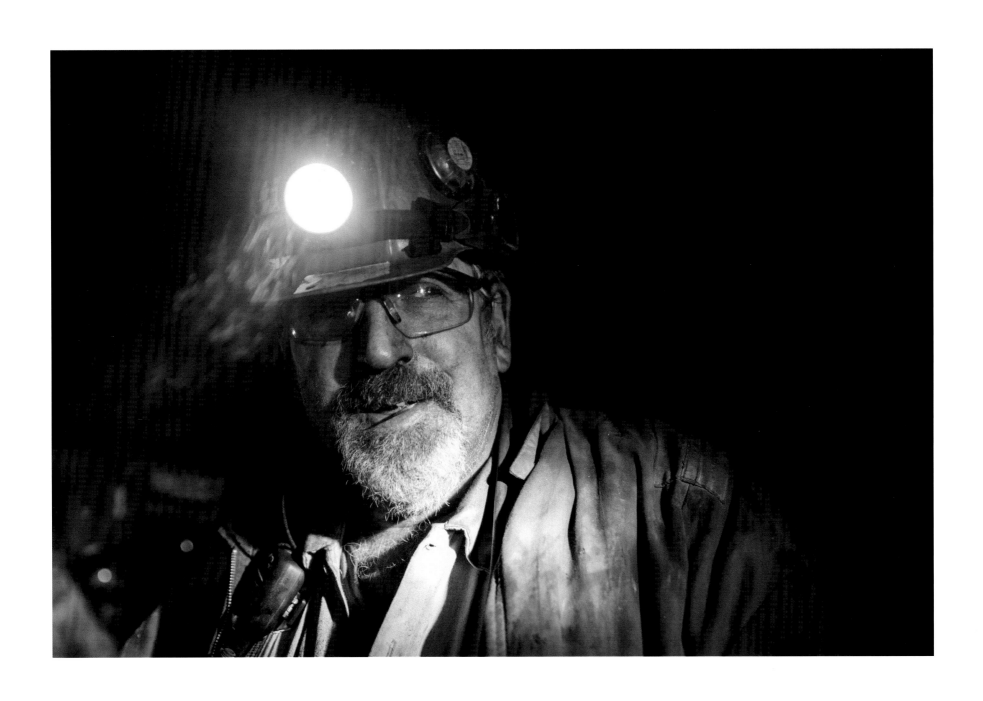

Deep, Deep in the Coal Mine - Davis, West Virginia - June 2018

Retired Coal Car With Patina - Keyser, West Virginia - June 2018

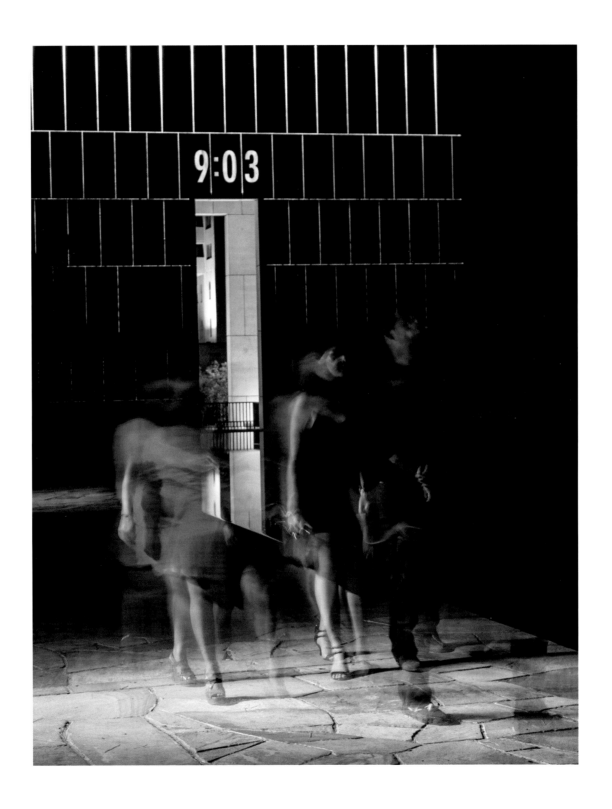

Oklahoma City Memorial - Oklahoma City, Oklahoma - August 2017

Car Light Trails - Gallup, New Mexico - August 2017

Richard Martin, photographer, author
Kingston Ontario, Canada

Mike, Sally and I have spent significant time together photographing in Cuba, Morocco, Mexico and, most recently, Colombia, all exotic and wonderful places to experience.

This image caught my attention during the initial edit due to its strong design and mysterious reality. It is a single image that caught a moment in time. The effective use of light, color, texture, and a keen sense of composition strengthen this brilliant work. The placement of the child in the picture space and its relationship to the environment creates a dynamic arrangement of shapes. There are layers of detail to explore and become absorbed in.

Reflecting the creative vision of the photographer, the design of the image and exceptional detail guides the viewer on a continual journey of visual discoveries. The true test of any image is its ability to entice the viewer to revisit over time and find new meanings.

Ultimately it demonstrates how reality can become transformed into the metaphorical, successfully combining the visual elements and emotional attitude that make a photograph exceptional.

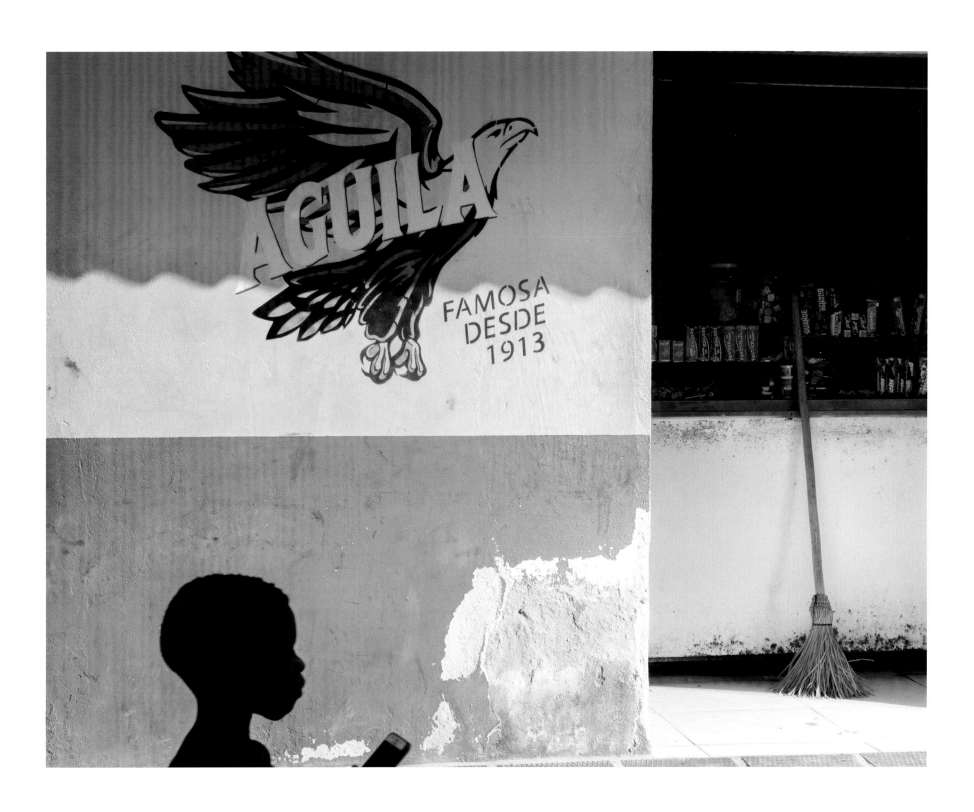

Photo Bomber - Isolte Santa Cruz, Colombia - January 2019

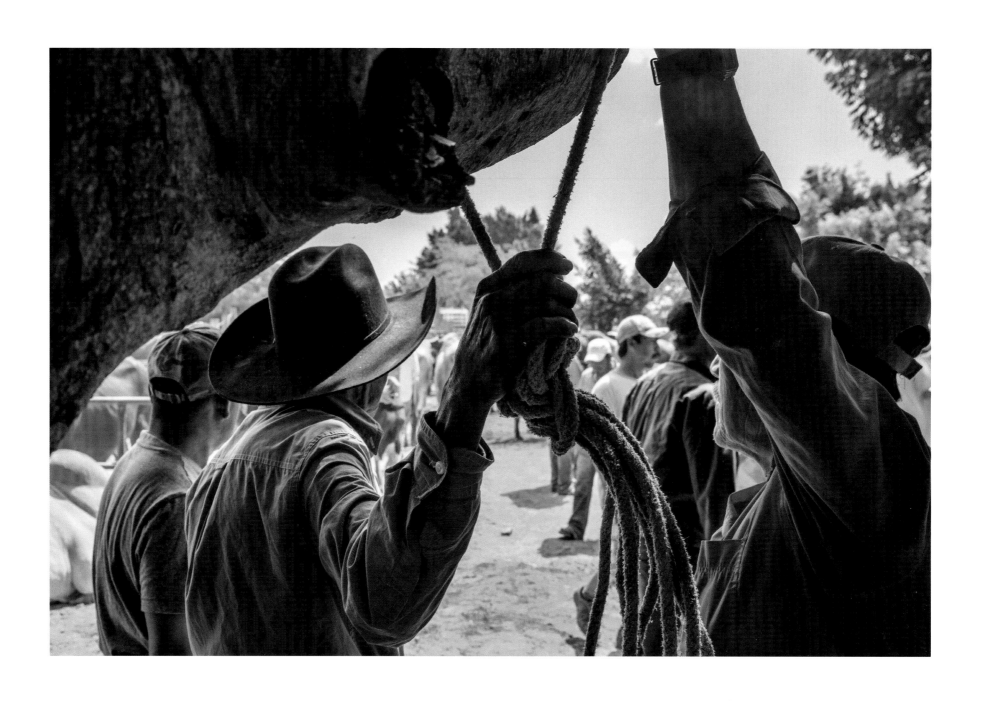

Under a Tree at the Cattle Sale - Oaxaca, Mexico - March 2018

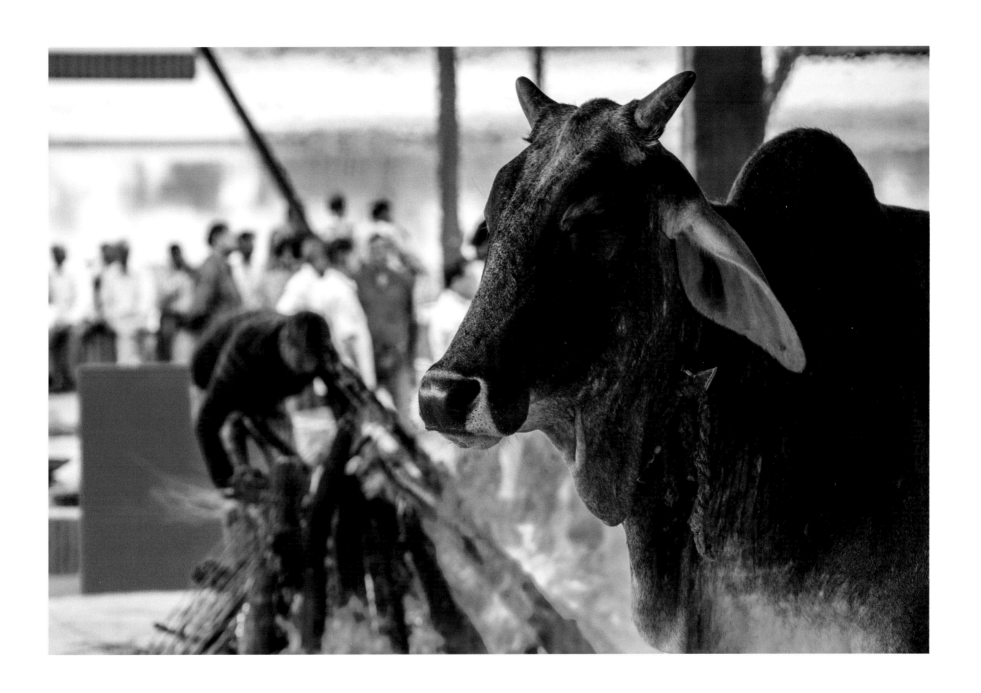

Sacred Cow at the Crematorium - Agra, India - March 2017

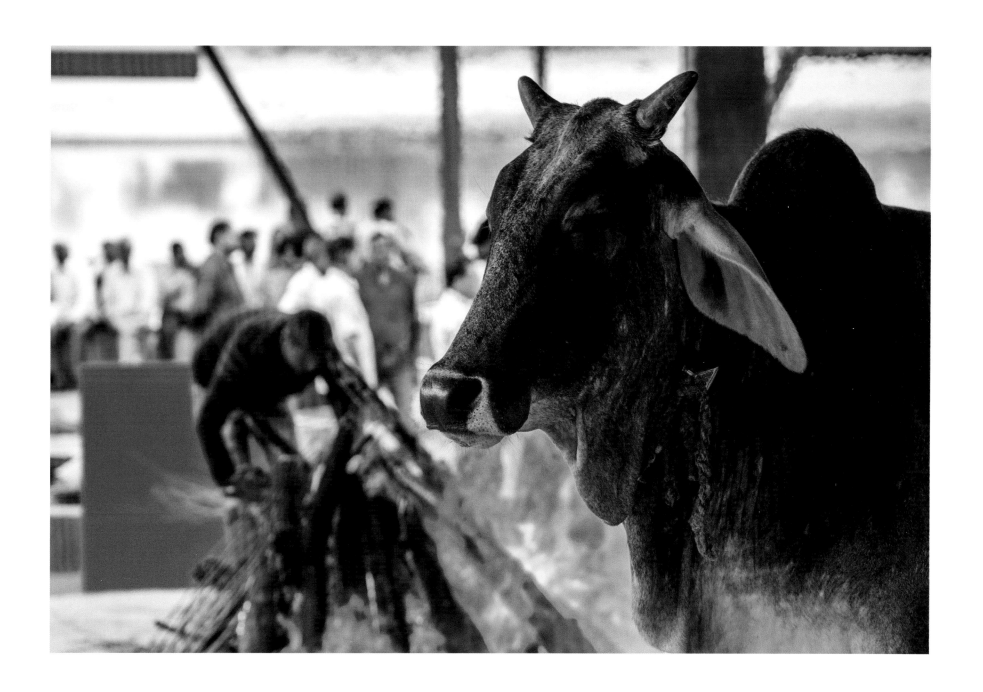

Sacred Cow at the Crematorium - Agra, India - March 2017

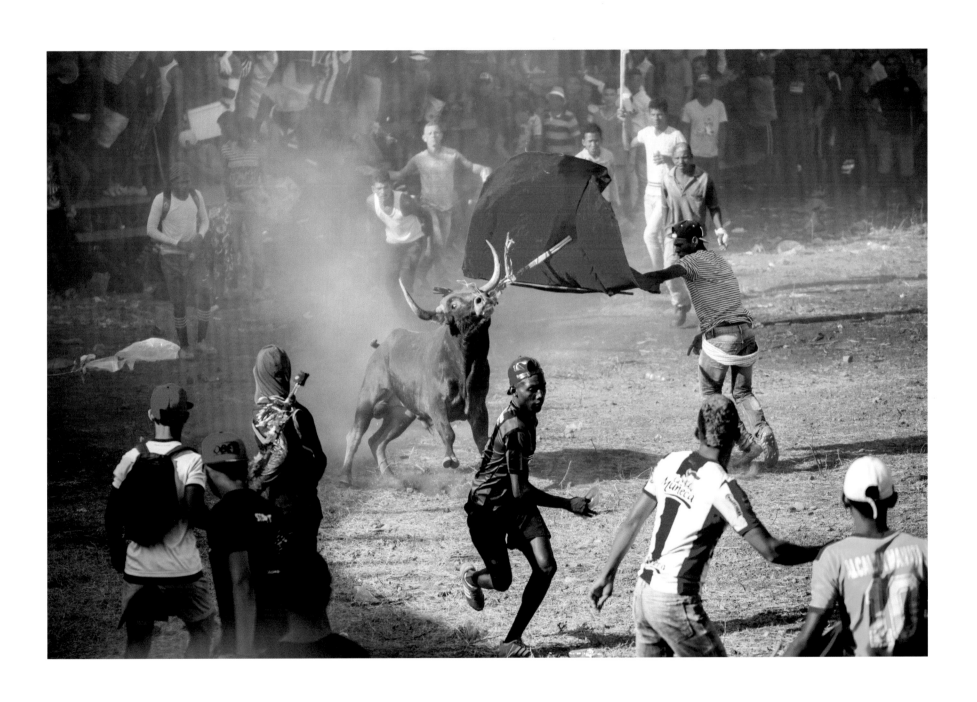

Colombian Correlajas - Northwest Colombia - February 2017

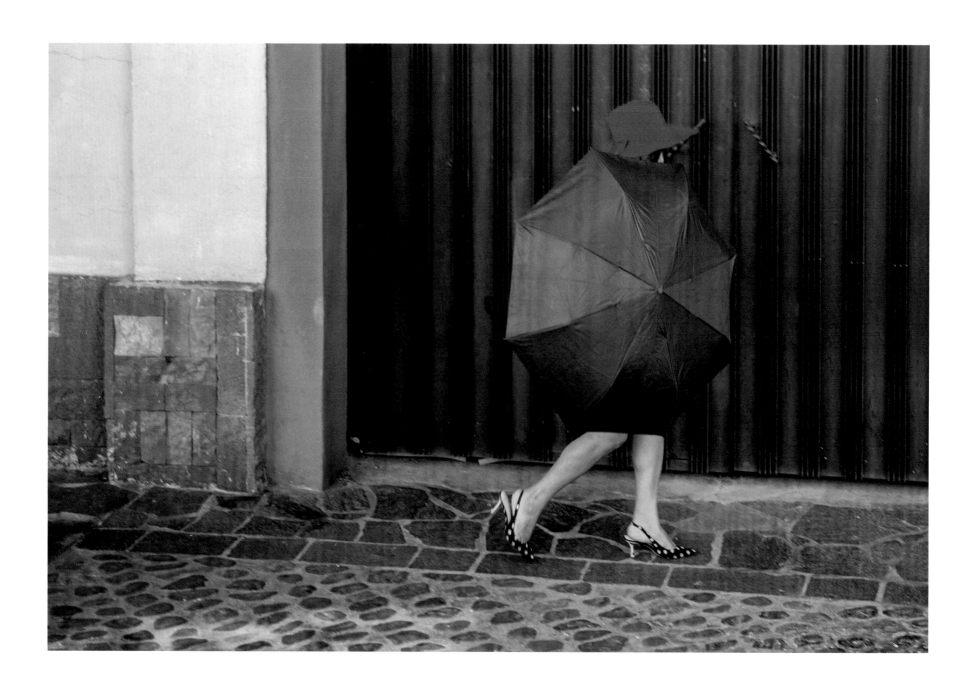

Woman in a Red Hat - Oaxaca, Mexico - 2018

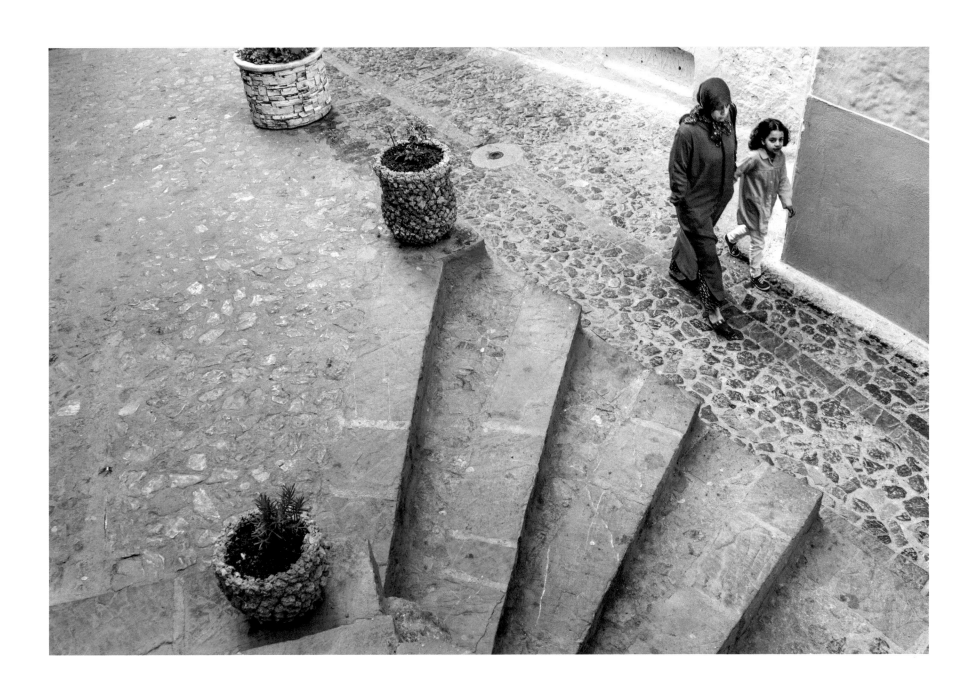

Mother and Child Walking - Chefchaouen, Morocco - April 2014

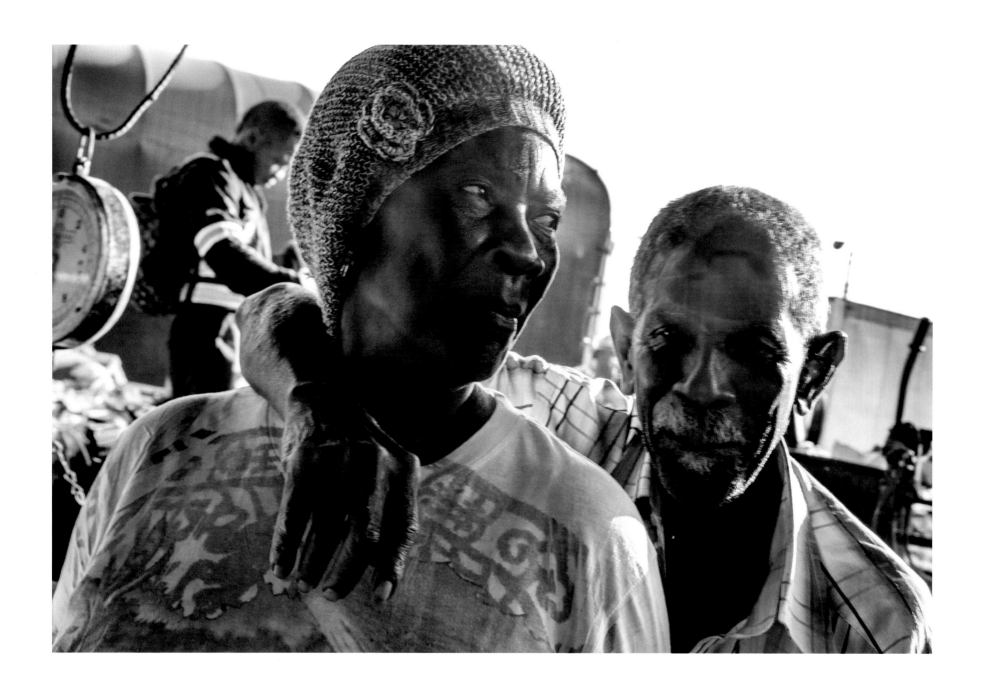

Connecting at the Market - Cartagena, Colombia - February 2017

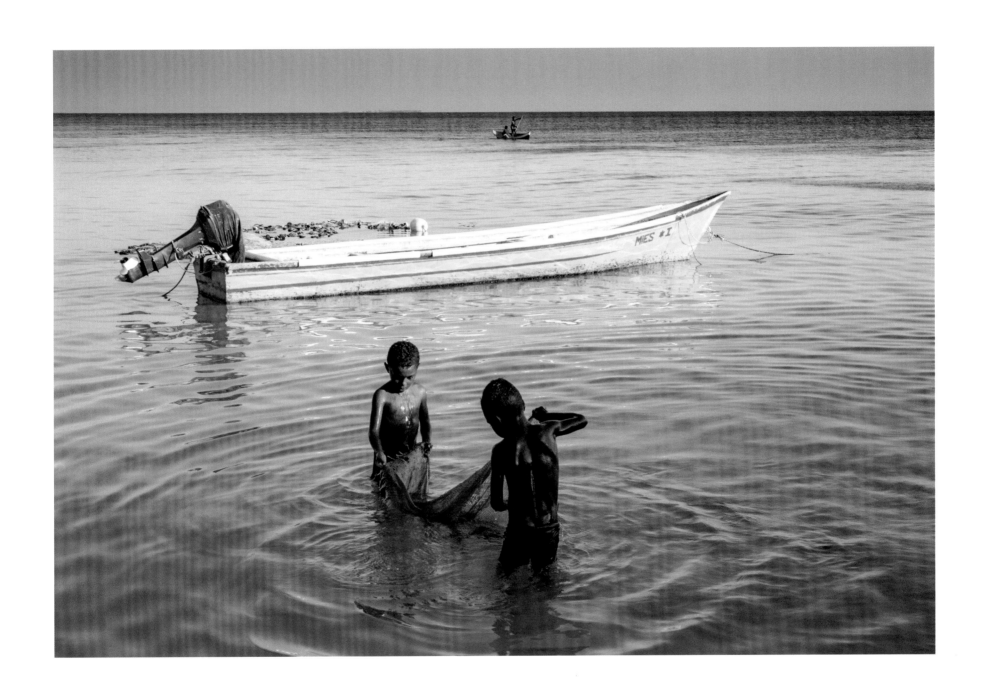

Two Island Boys and a Boat - Isla Mucura, Colombia - January 2019

In early 2017, Sally and I hired a young photojournalist named Joaquin from Cartagena to show us some sites that are not in the tour books. This was exactly how we like to participate in different cultures.

In the 1800s, a slave ship ran aground off the Colombian coast. The slaves who escaped were given refuge by the government, and the town of Palenque was established for them and their descendants. Joaquin had a friend in Palenque, and we were welcomed as visitors. The photo on the opposite page was taken as six local women gathered at a home.

Two other moments captured during this trip appear in this book. One stop was in a remote town to see a Colombian style bullfight. In the local style, known as a Correlajas, the daring young people get in the ring, and the bulls are then released. Pandemonium rules. A photo taken from the rickety stands appears on page 85.

Another adventure was to the business district of Cartagena to photograph Paso Fino horses warming up on a nearby beach for a parade through the streets. For the photograph appearing on page 125, I lay in the sand to get a better perspective as the horses headed to the streets, their staccato gait sending the sand flying.

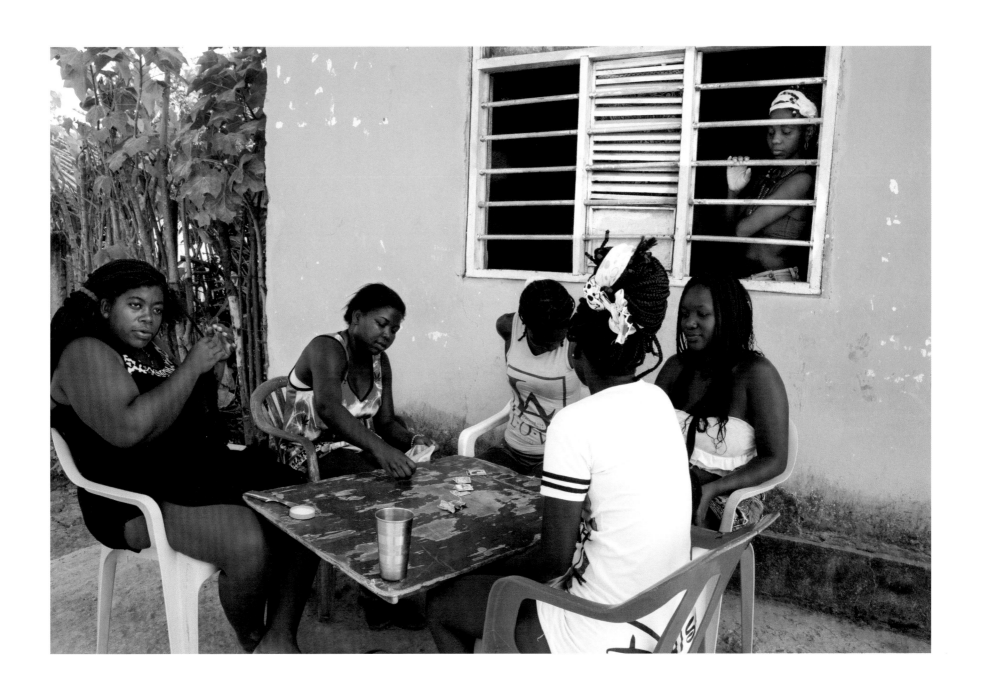

The Gathering - Palenque, Colombia - February 2017

A Coincidence of Turquoise - Trinidad, Cuba - February 2012

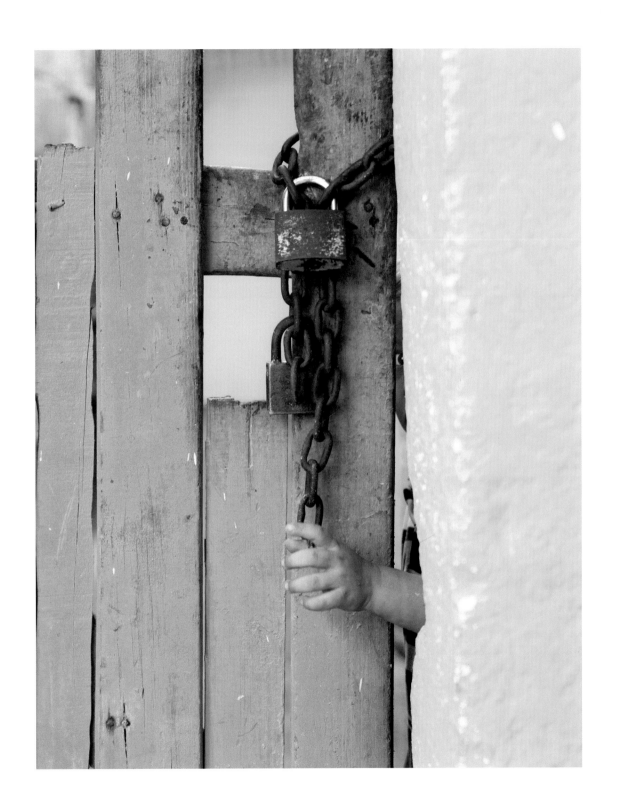

Look for the Hidden Eye - Isolte Santa Cruz, Colombia - January 2019

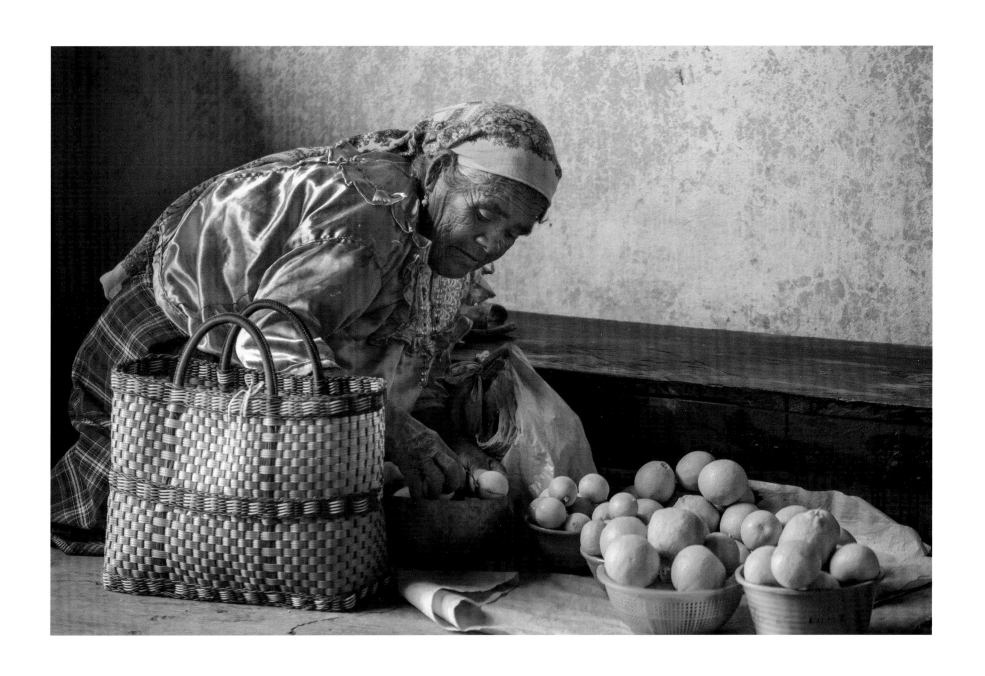

The Fruit Vendor - Oaxaca, Mexico - February 2016

Sally and I first visited Cuba in 2012. At that time schools would regularly invite photographers into the school to photograph the students. Given security measures in the U.S., this seemed very odd.

Times have changed, and I understand that Cuban rules now forbid this practice. But sometimes there are exceptions. We were in Remedios, Cuba, in January 2020. I was photographing masses of young children arriving at the Escuela "Frank País García." I stood outside, minding the rules, when, to my surprise, a teacher waved at me to come on in. I did not hesitate.

School began with the singing of the Cuban National Anthem in the open courtyard, shown in the photo below. When the singing ended, I began taking photos of individual students. The young man on the opposite page caught my attention. He stood out from the crowd.

I see this photo as a symbol of Cuba's future. Pictures of Fidel and Che remain present throughout Cuba as symbols of the past. The education system is superb, and Cuba's literacy rate is now extremely high. Here we have a boy who looks like a rebel, dressed in black when all the others are wearing white. But I see the boy as a potential "rock star" for Cuba's future.

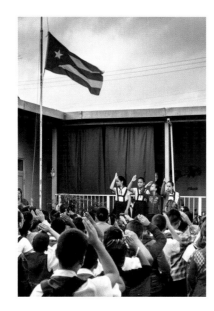

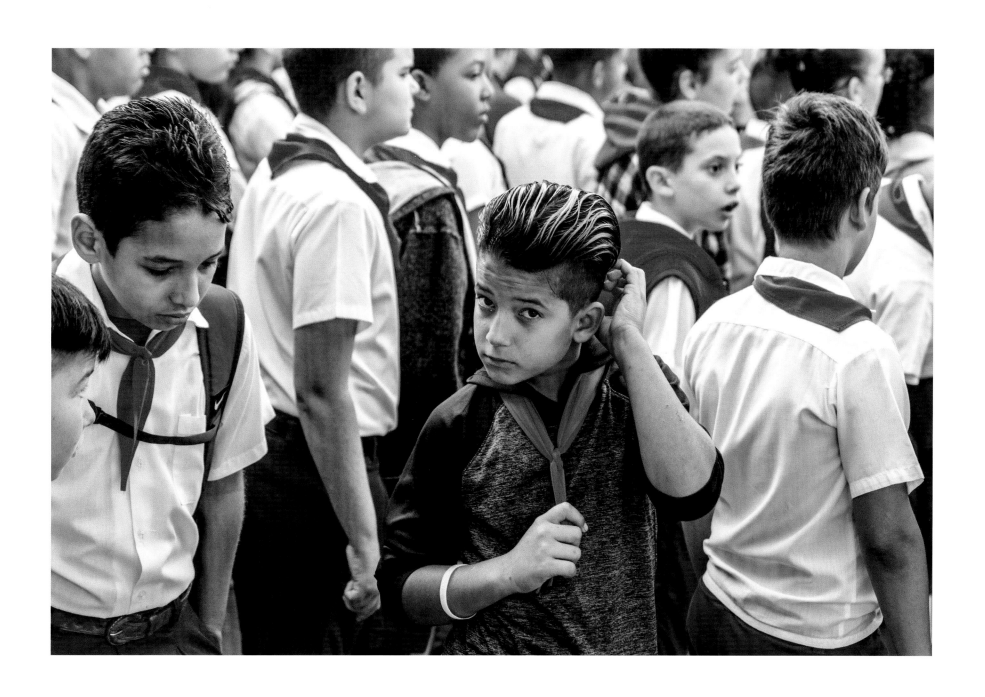

Rebel and Future Cuban Rock Star - Remedios, Cuba - January 2020

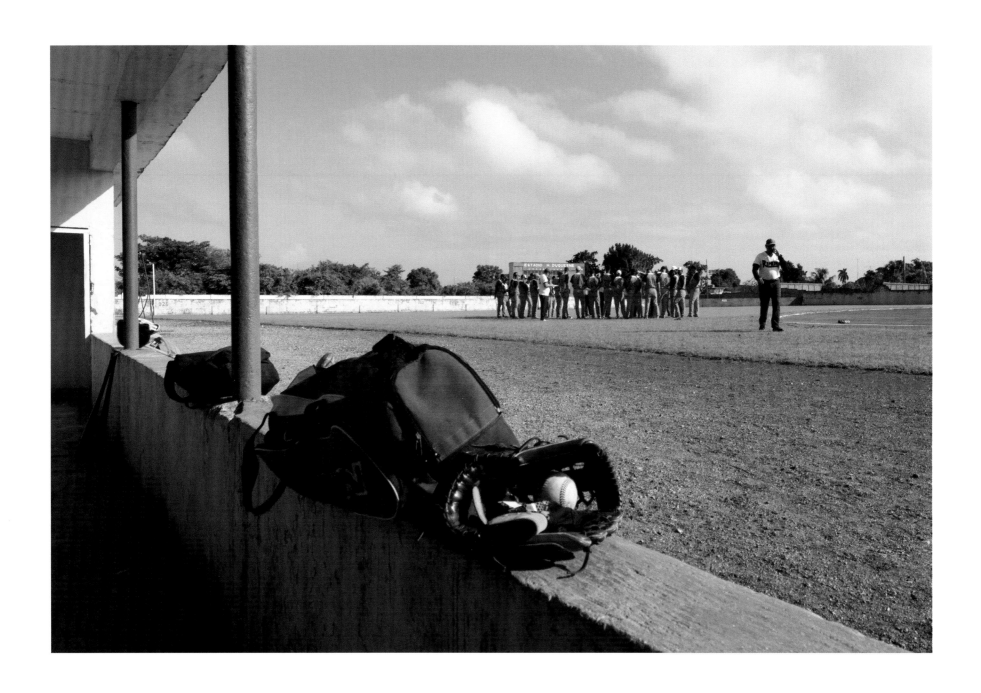

View from the Dugout - Remedios, Cuba - January 2020

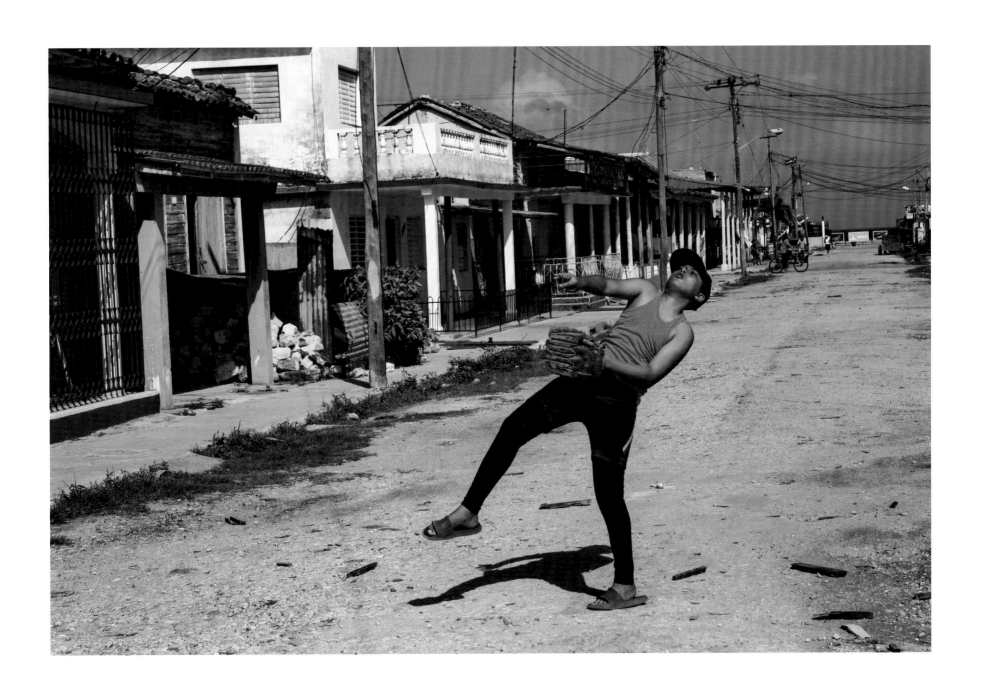

Big League Practice in a Small Town - Maria Escobar Laredo, Cuba - January 2020

Nevada Wier, photographer
Santa Fe, New Mexico

Mike and Sally have travelled with me in Vietnam, India, Iceland and Camaguey, Cuba.

I was with Mike in Cuba the morning he made this image. I have said many times to my photography students, "You are just interpreting what you see in a photograph; distill your vision to essentials." That is exactly what Mike did. It is not just a pretty image of train tracks in the morning, it is an image about light and color and design.

One of challenges of travel photography is the very reason we love to travel – it is new and intriguing. The sights are fun; the smells are different; the joy of being somewhere outside our normal is intoxicating and perhaps challenging. That is part of the reason we love to travel. However, a photographer has to rise above just snapping, "Oh, I like that! CLICK." We must make an interesting image of that interesting place. And Mike knows how to do this!

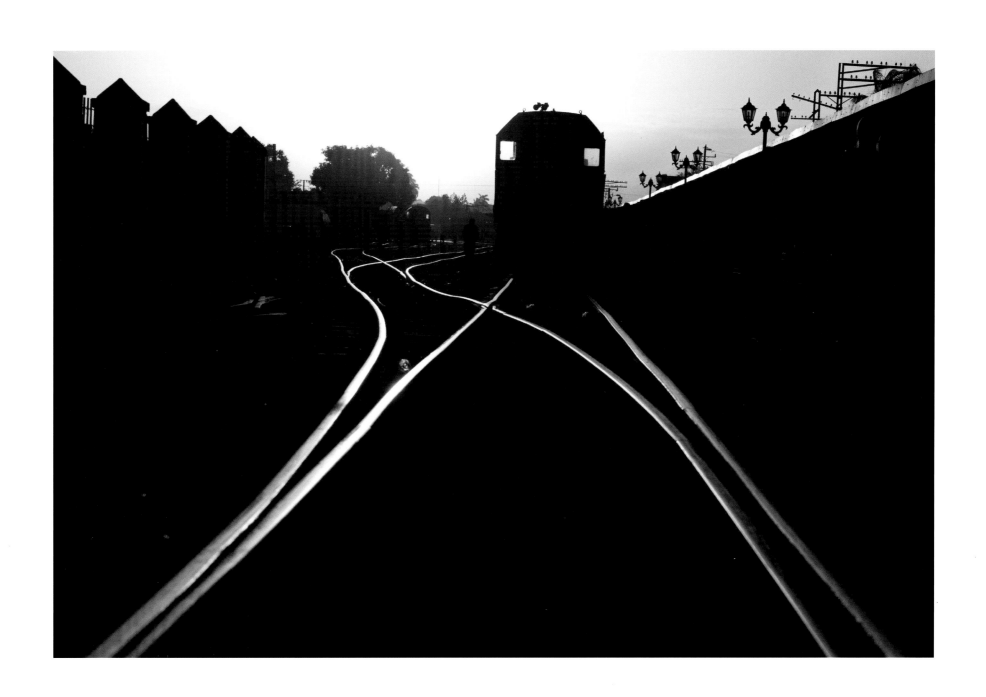

Converging Lines at Sunrise - Camaguey, Cuba - March 2020

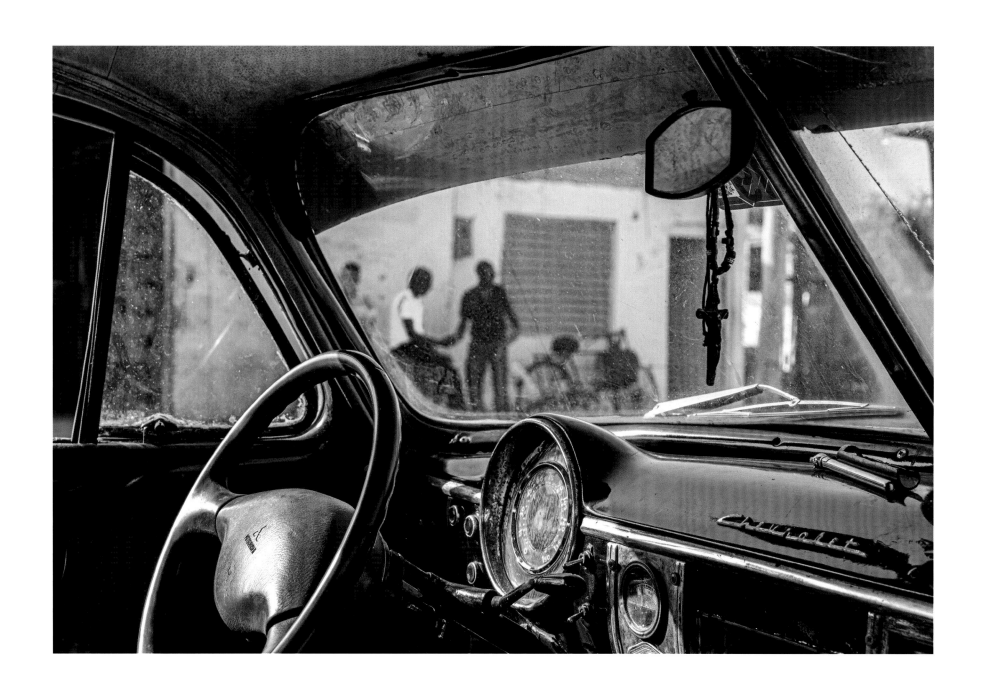

Looking Through an Old Car Window - Maria Escobar Laredo, Cuba - January 2020

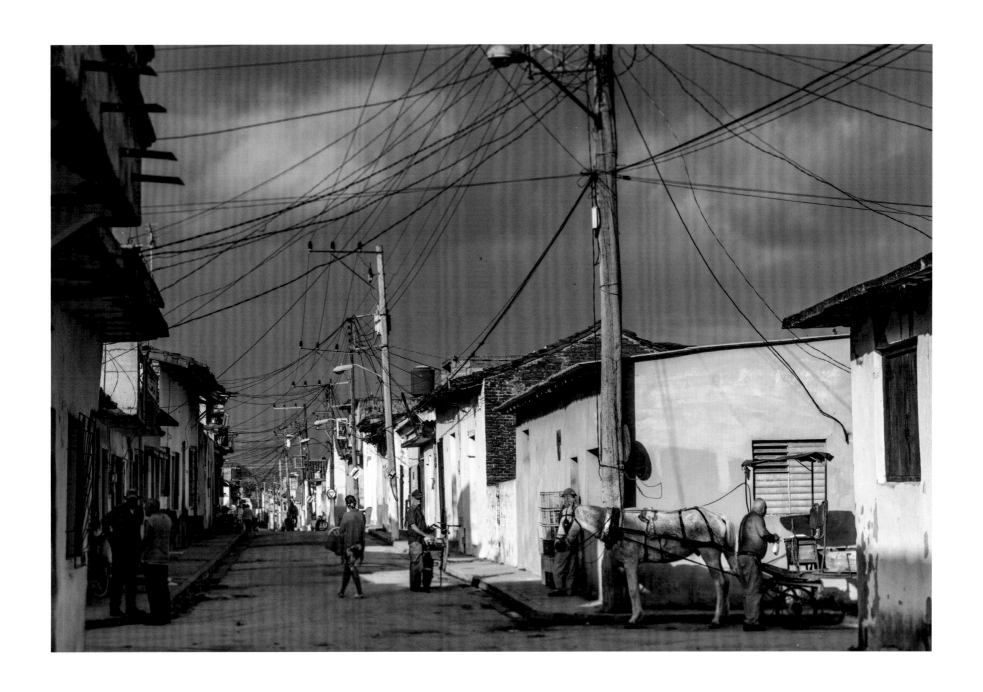

Life in the Streets - Sancti Spiritus, Cuba - January 2020

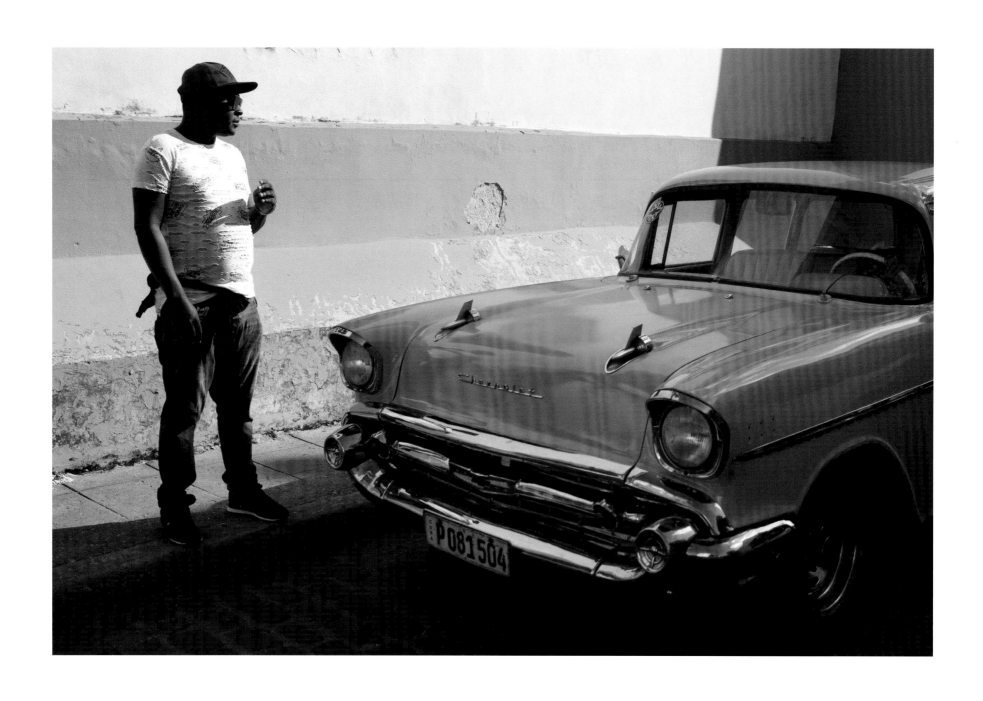

Admiring a Classic - Camaguey, Cuba - March 2020

Coffee Shop Treat - Oaxaca, Mexico - February 2016

Arched Doorway - Oaxaca, Mexico - February 2016

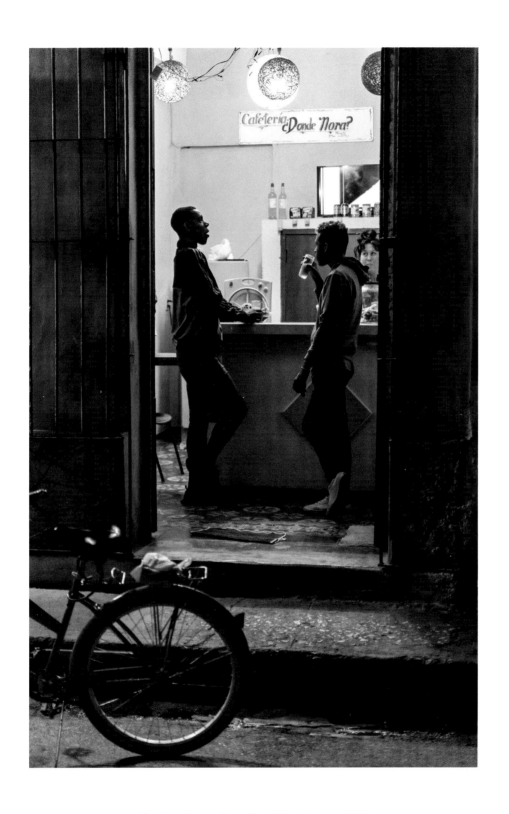

Sharing a Story - Remedios, Cuba - January 2020

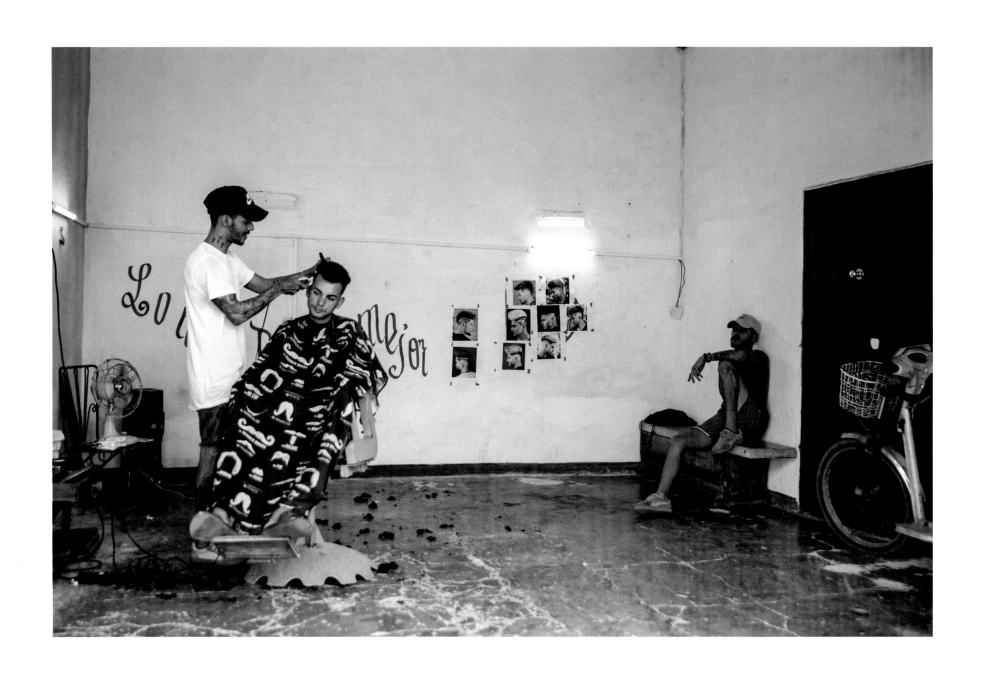

Center for Social Exchange - Sancti Spiritus, Cuba - January 2020

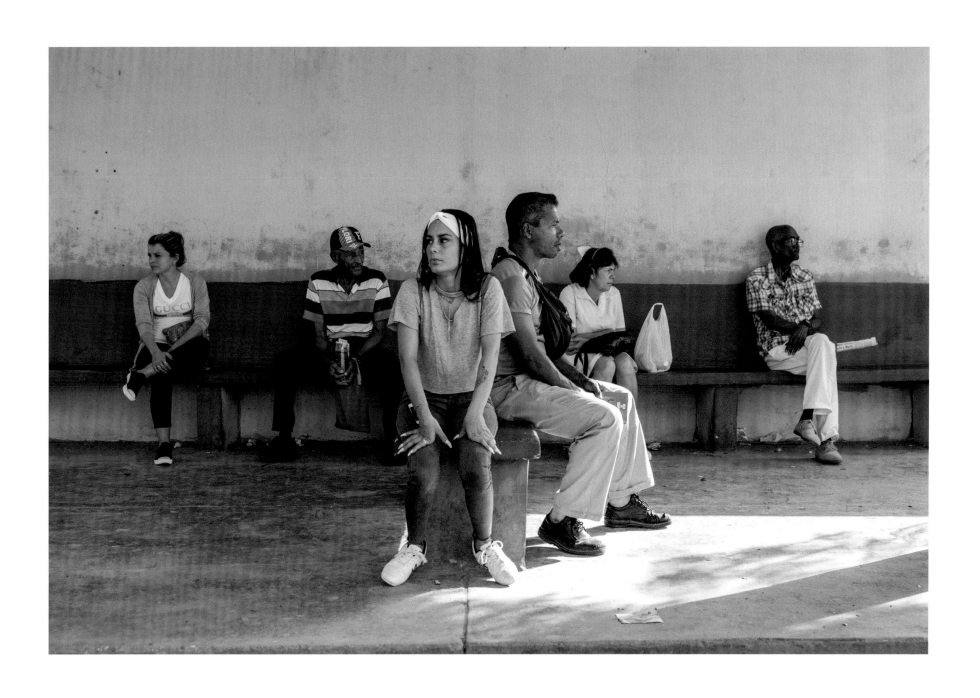

At the Bus Stop - Camaguey, Cuba - March 2020

Joseph-Phillipe Bevillard, photographer
Killaloe, County Clare, Ireland

The Irish Travellers are an Irish ethnic minority who, since the early fourteenth century, have lived a nomadic life much like gypsies. Like many minorities, the Travellers have faced discrimination. In recent years, the government has discouraged their nomadic lifestyle and most Travellers now reside among other Travellers in housing provided by the state.

I have in recent years dedicated a good part of my life to helping the Travellers improve their lives. Mike and Sally were also intrigued by this minority group and joined me to meet some of the families. The Traveller community welcomed Mike and Sally into their homes.

Travellers treasure large families. Seven to fifteen children are commonplace. These children are fun-loving inquisitive individuals, and they love being photographed.

Mike has a calm, genuine demeanor and often interacted first by talking with the parents and then playing with the kids, often letting them use his camera. Everyone totally relaxed, and Mike was able to capture amazing, natural photographs. The families have asked me when Mike and Sally will return to Ireland.

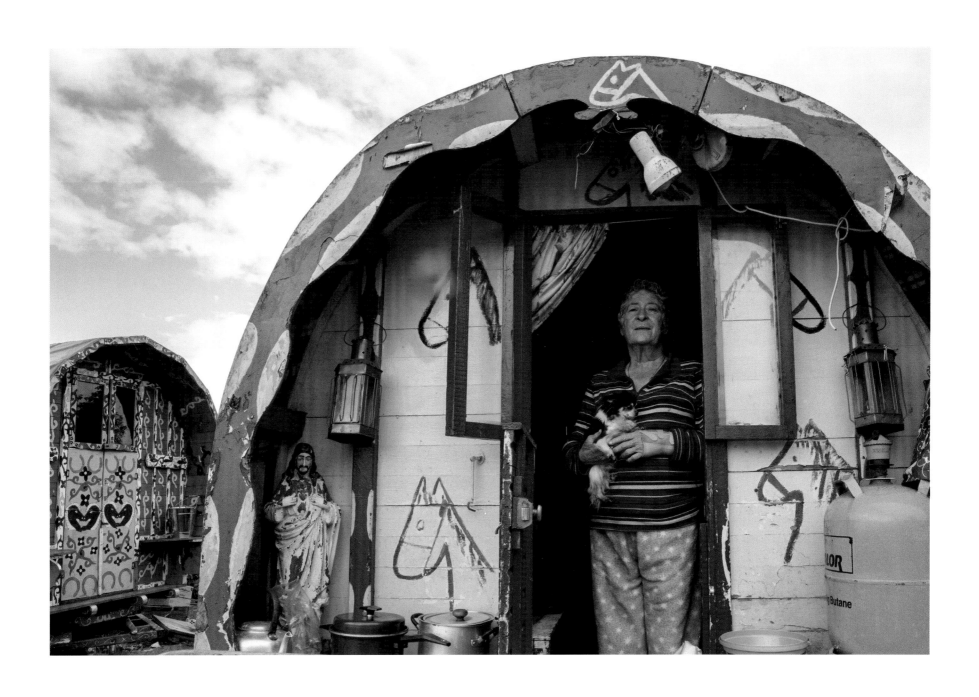

Nellie Stands Tall at the Door - Cashel, Ireland - June 2019

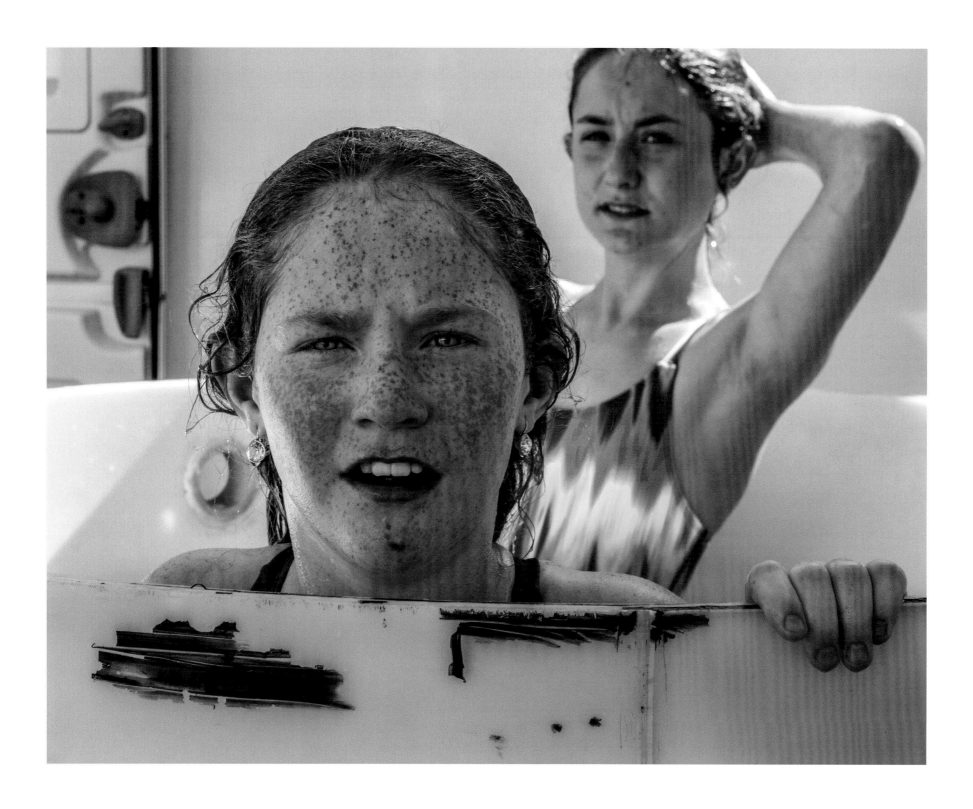

Freckled Traveller Teenager - Limerick, Ireland - June 2019

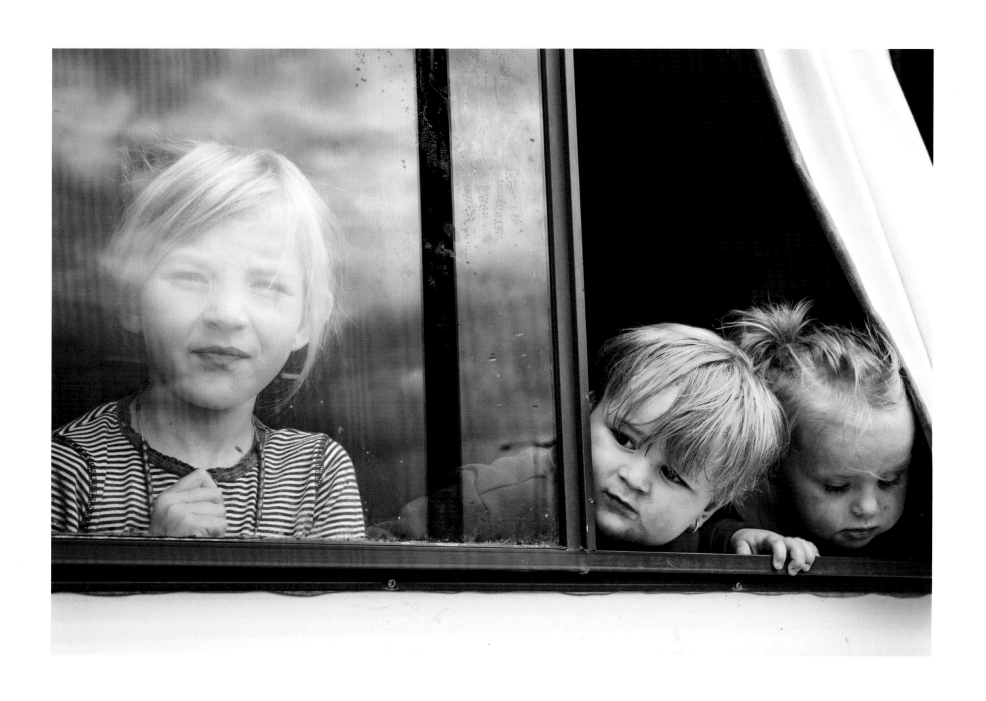

Three Reilly Siblings at the Window - Cashel, Ireland - June 2019

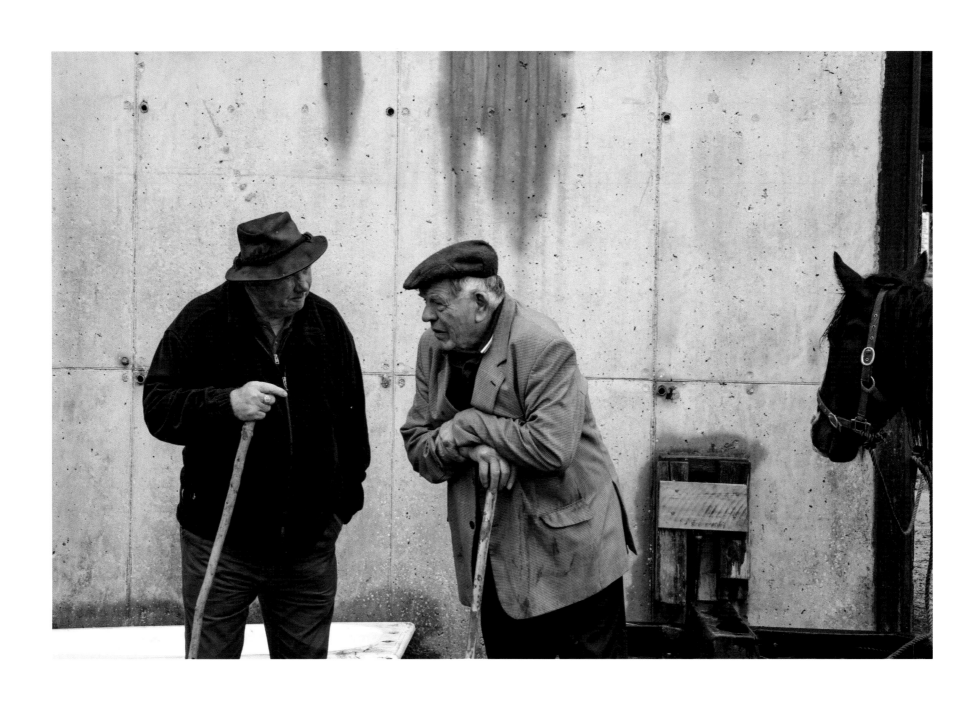

Discussing the Business of the Day - Spancil Hill, Ireland - June 2019

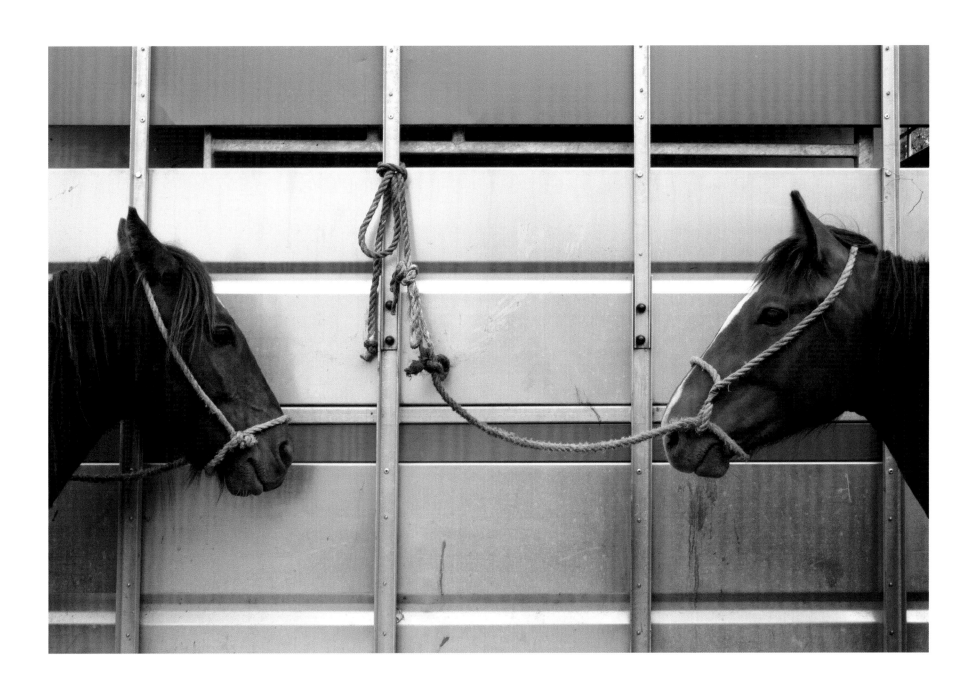

Two Horses Face Off - Spancil Hill, Ireland - June 2019

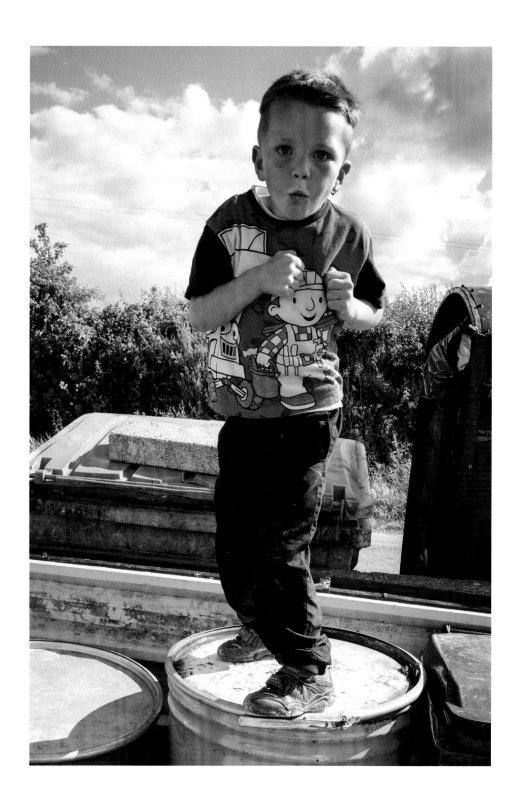

Traveller Sparring for Show - Cashel, Ireland - June 2019

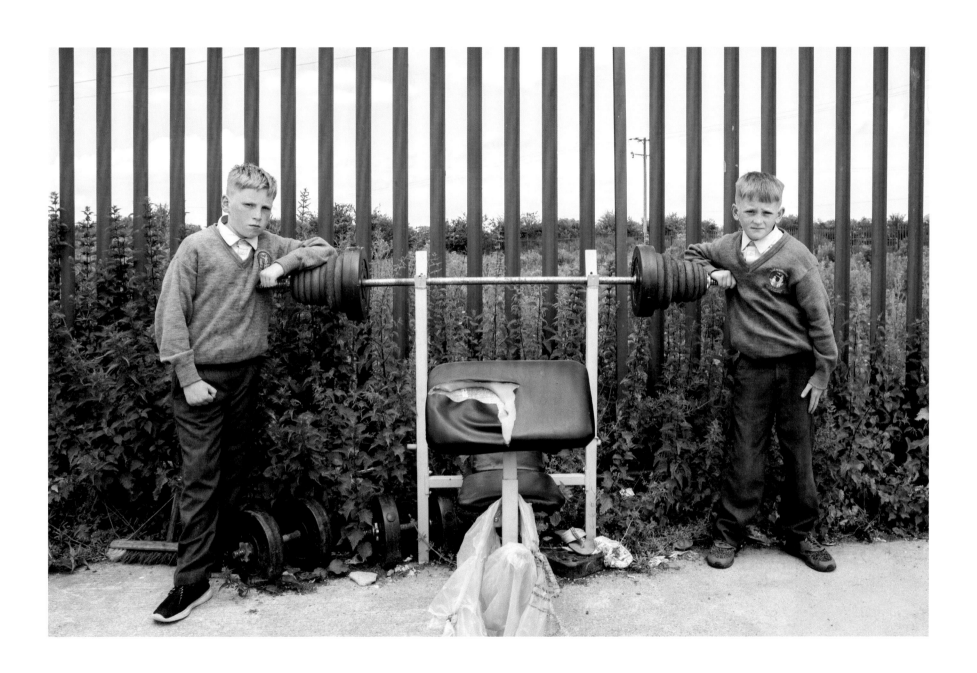

Traveller Brothers Pose with Barbells - Cashel, Ireland - June 2019

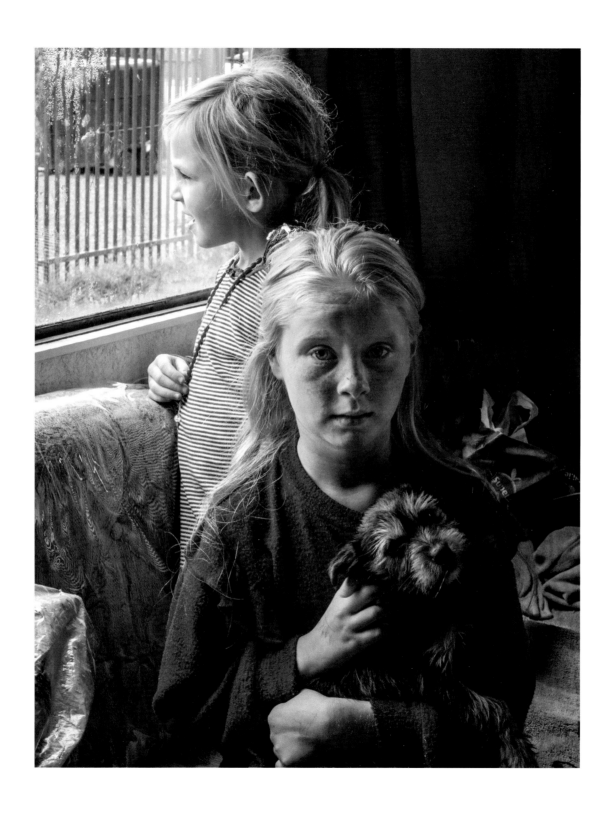

Reilly Sisters in Their Living Room - Cashel, Ireland - June 2019

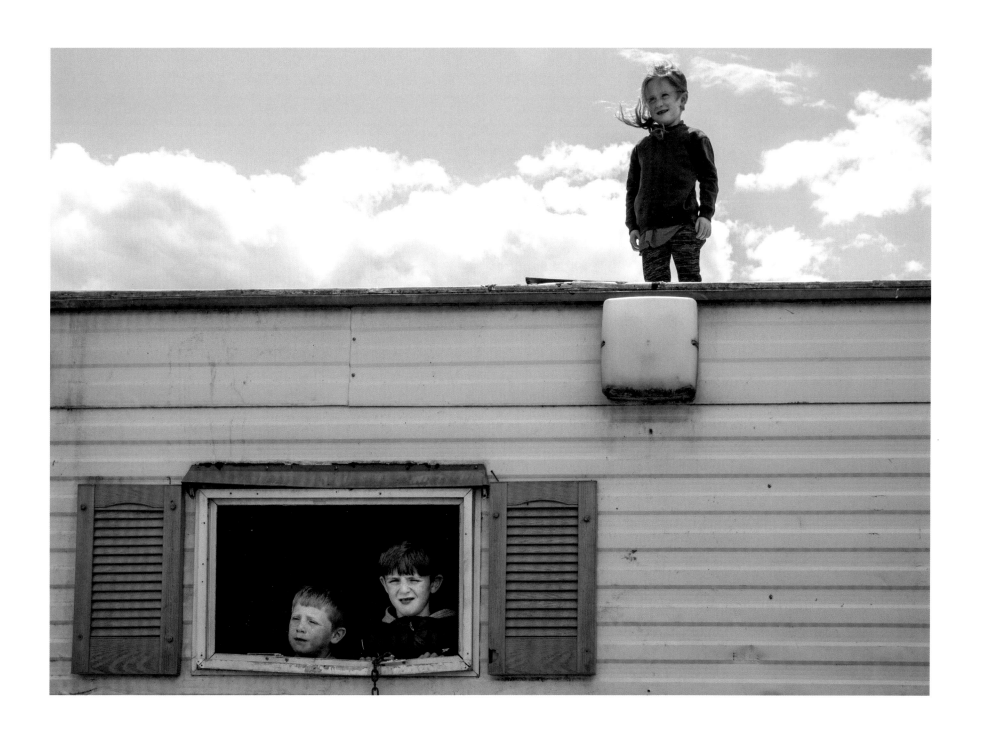

Where Have All My Brothers Gone? - Cashel, Ireland - June 2019

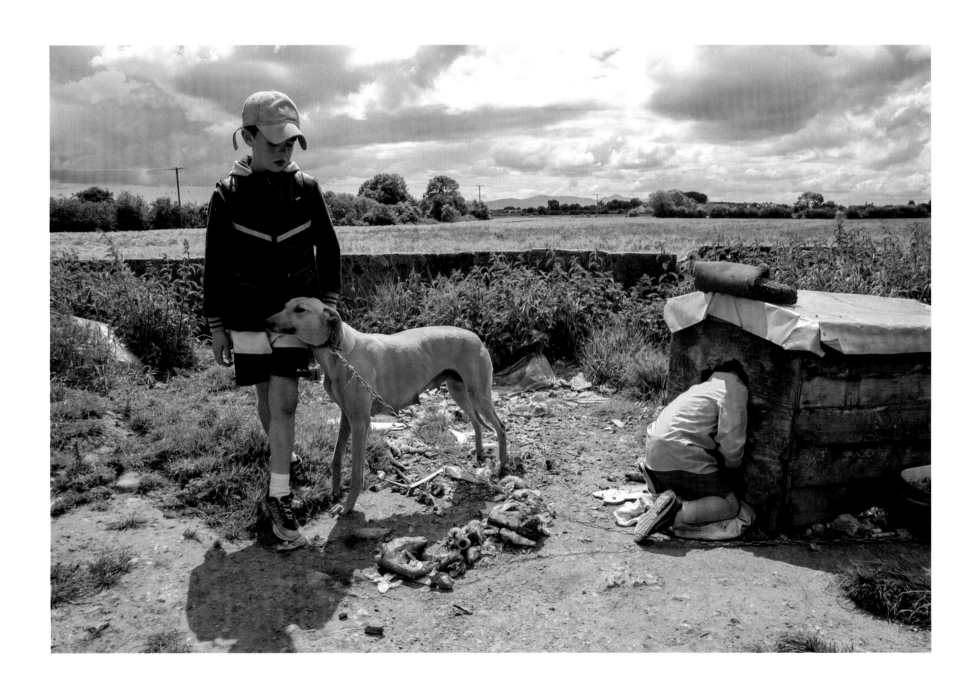

In the Doghouse - Cashel, Ireland - June 2019

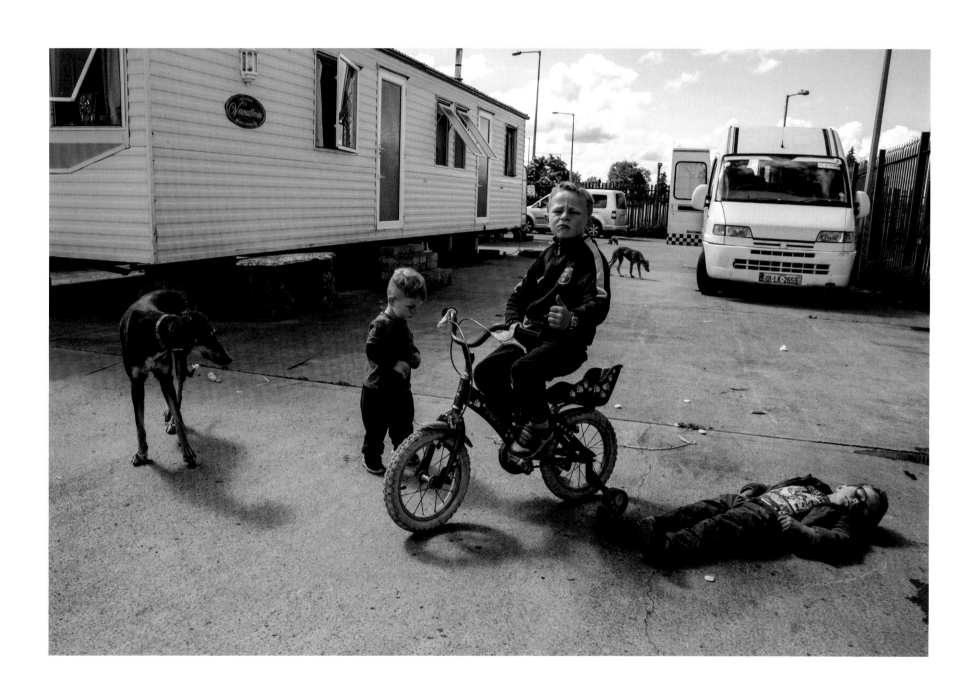

Traveller Boy Plays Dead for the Photo - Cashel, Ireland - June 2019

Catholicism is the religion of most Travellers, and religious services play an important part in their culture. A young child, one of the Reilly family, had died a year before our visit to Ireland, and the greater Reilly family was gathering at the cemetery for a mass to celebrate the one-year anniversary of the child's death. There were white and blue balloons flying above that had the words "Happy Anniversary" inscribed on them. The family prayed to God and honored the child's place in heaven.

We were encouraged to photograph the celebration. At first, I felt reluctant, like I was imposing on a very private moment, but then I realized that this was a celebration and not a time for mourning. I moved beside the elaborate gravestone so I could view the priest and those surrounding him. I was fascinated by the interaction among those attending, particularly the young girl with her hands held out in prayer.

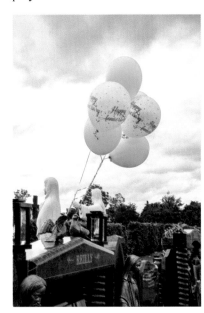

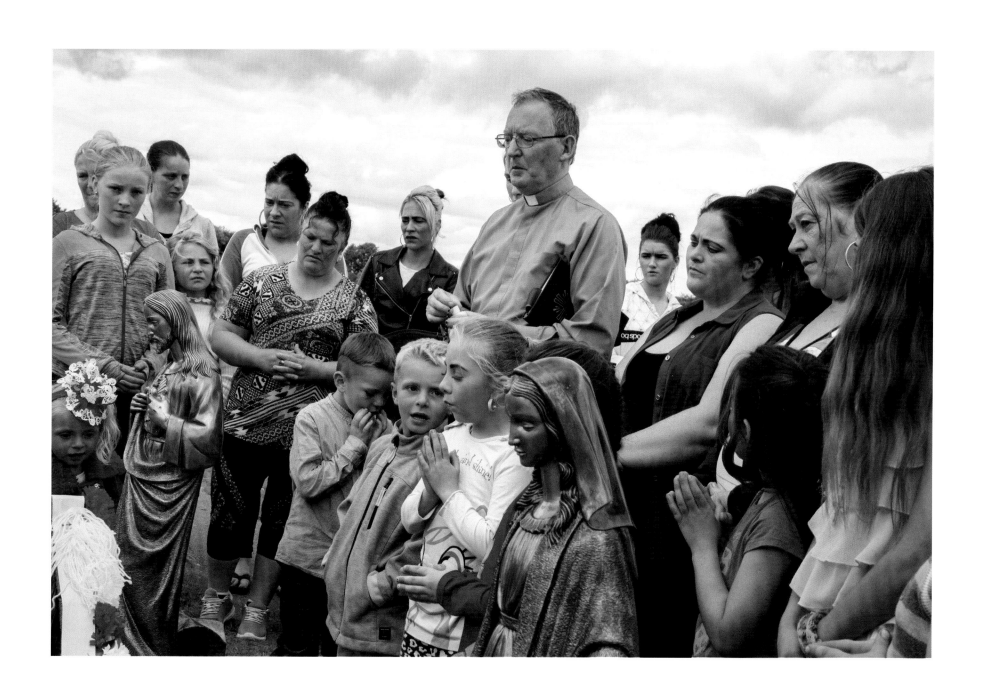

Graveside Mass of Celebration - Limerick, Ireland - June 2019

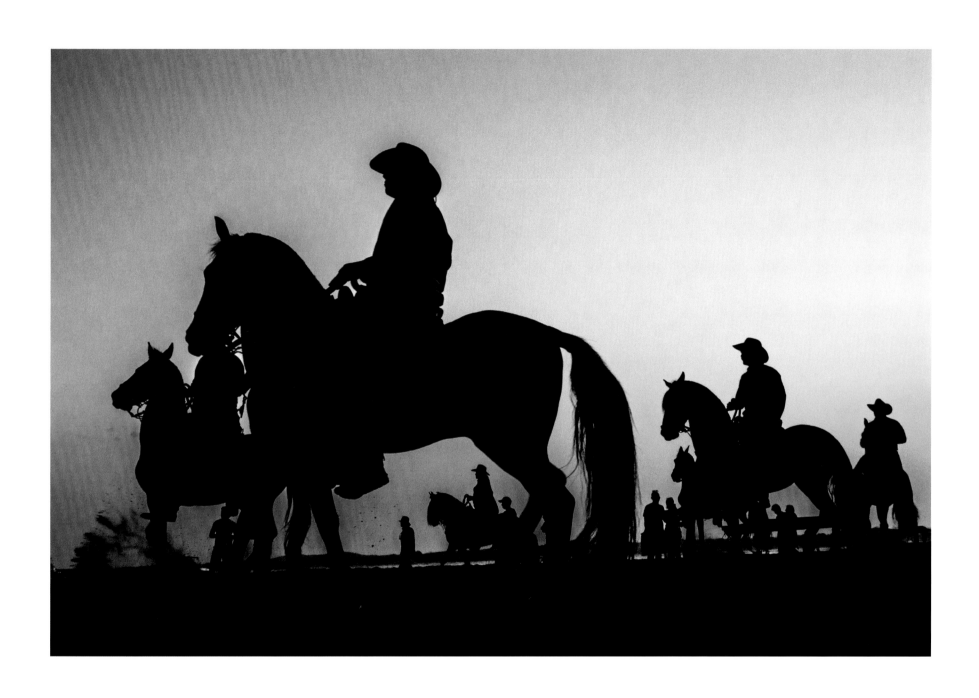

Paso Fino Horses Prepare for a Parade - Cartagena, Colombia - February 2017

Stranger at the Window - Jaipur, India - March 2017

Doorman at the Greenbrier Resort- White Sulphur Springs, West Virginia - May 2013

The Eyes are the Window to the Soul - Rabat, Morocco - April 2014

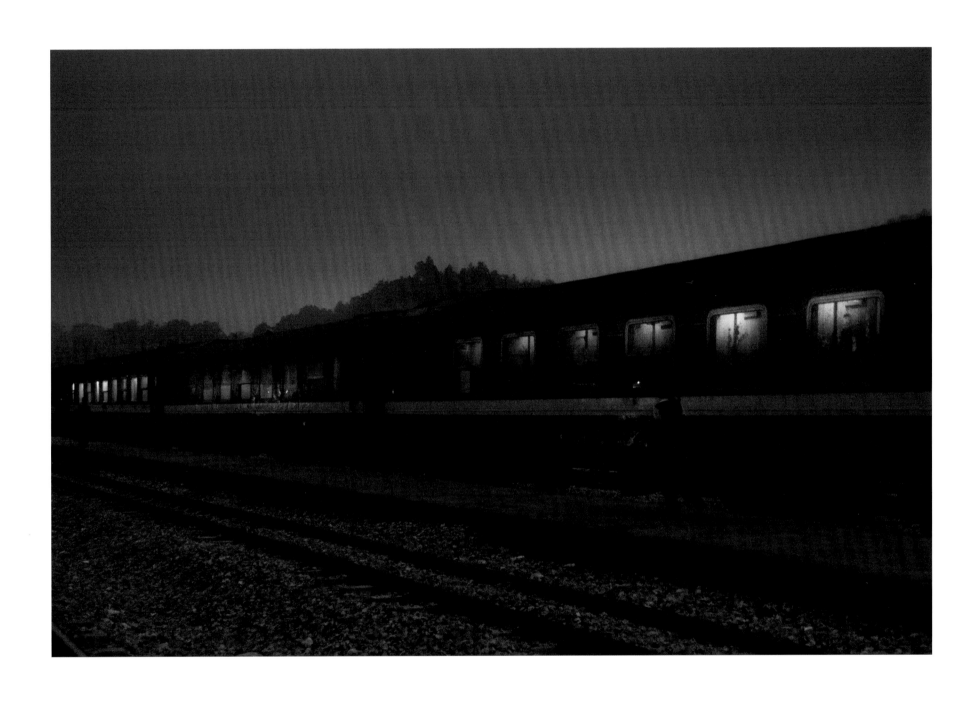

Overnight Train to Sapa, Vietnam - Sapa, Vietnam - March 2015

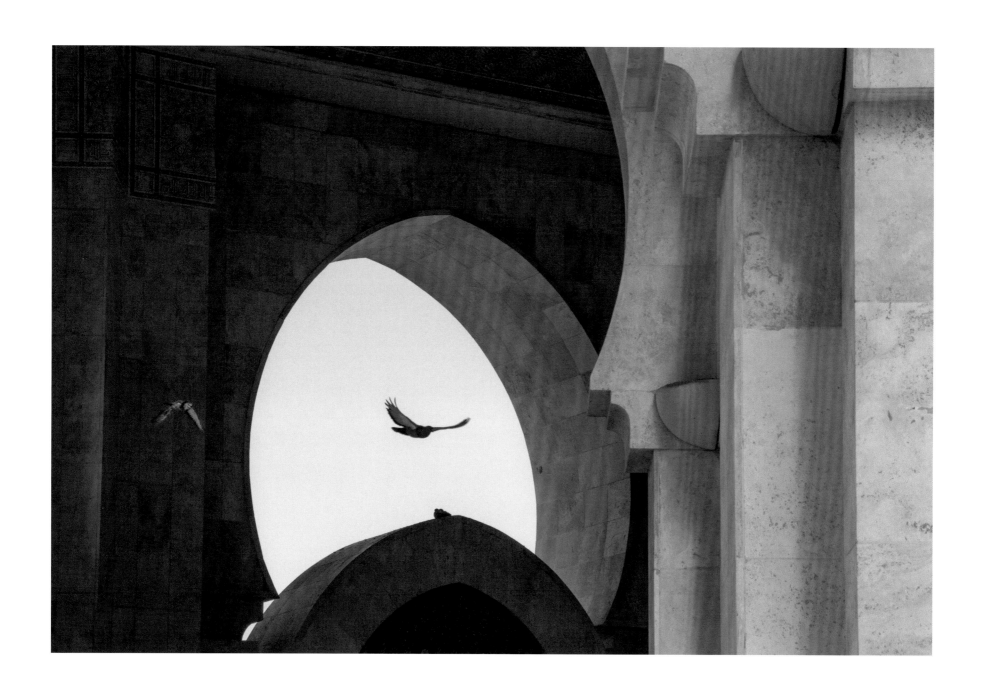

Birds at the Mosque - Casablanca, Morocco - April 2014

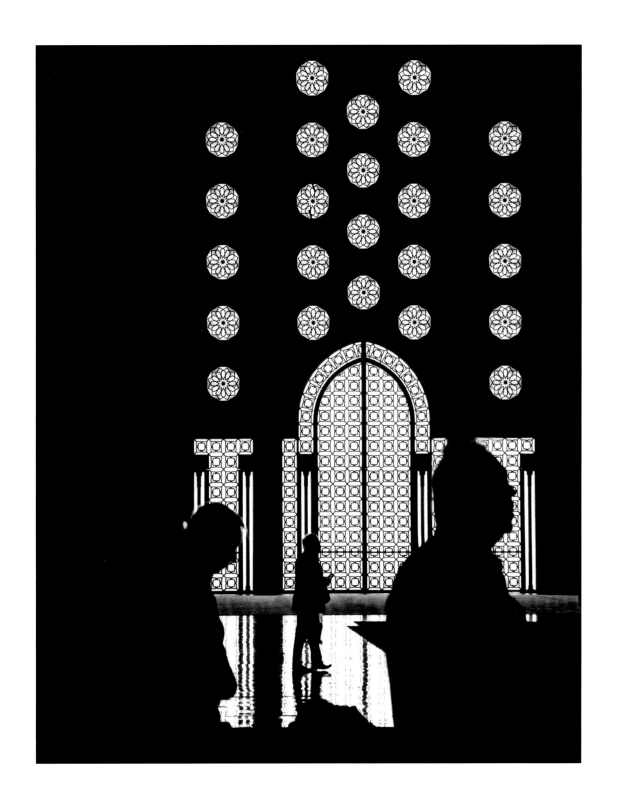

On the Way to Prayer - Casablanca, Morocco - April 2014

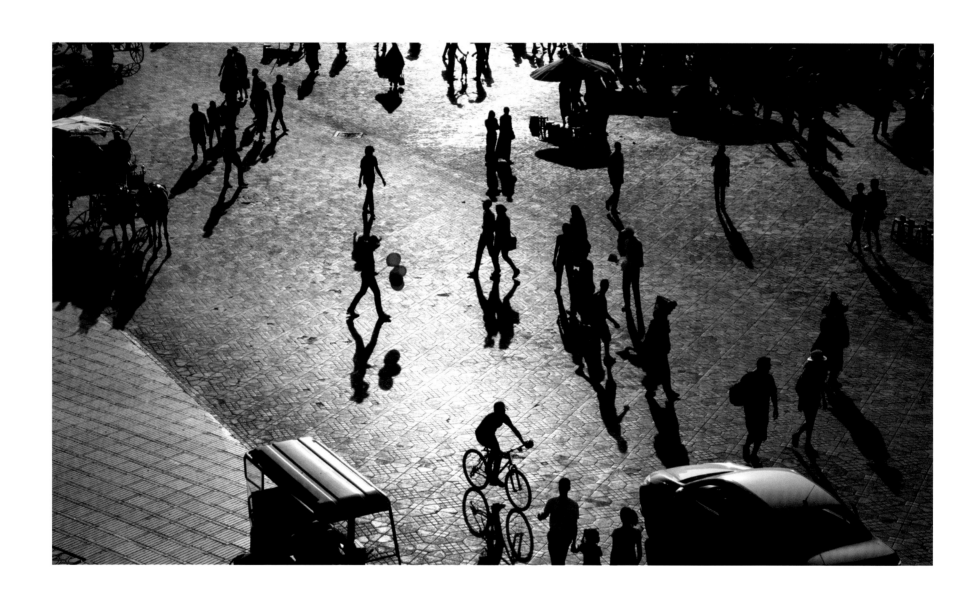

The Red Balloon - Marrakech, Morocco - May 2014

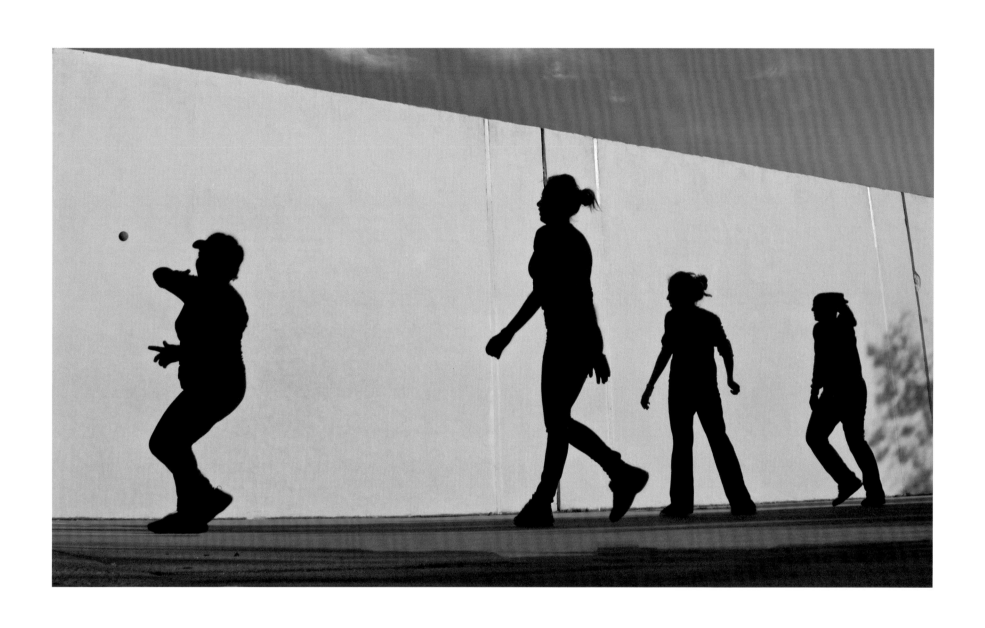

Ladies' Game at Coney Island - Coney Island, New York - October 2011

The Holi Festival is an ancient Hindu festival where thousands gather to celebrate the coming of spring and the triumph of good over evil. Festivals occur in many cities, and people celebrate by smearing paint pigments on each other and by throwing colored paint powder in the air. Anyone is fair game to be smeared and it is all in fun.

Nevada Wier has organized many trips to participate in the Holi celebrations in India, and we joined her in 2017 to experience the ritual. Paint dust was everywhere, and we went through an elaborate taping each morning to protect our photo equipment. Then we jumped into the action, and by the end of the day we were inevitably covered in paint.

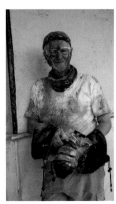 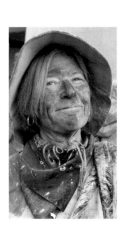

Photo by Sally Harris

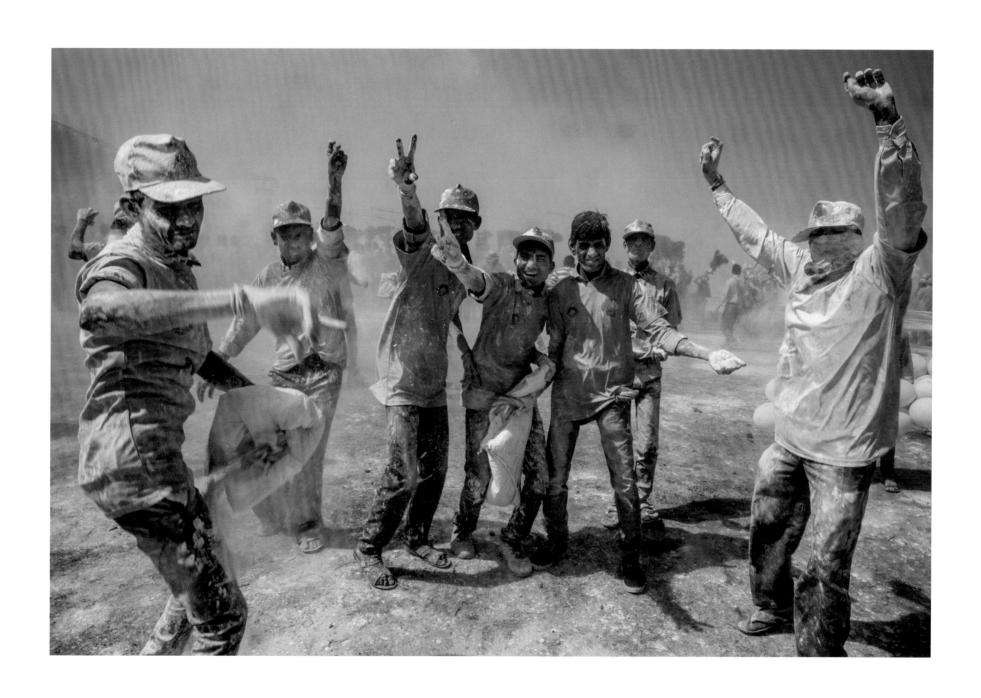

Holi Festival Explosion of Yellow - Mathura, India - March 2017

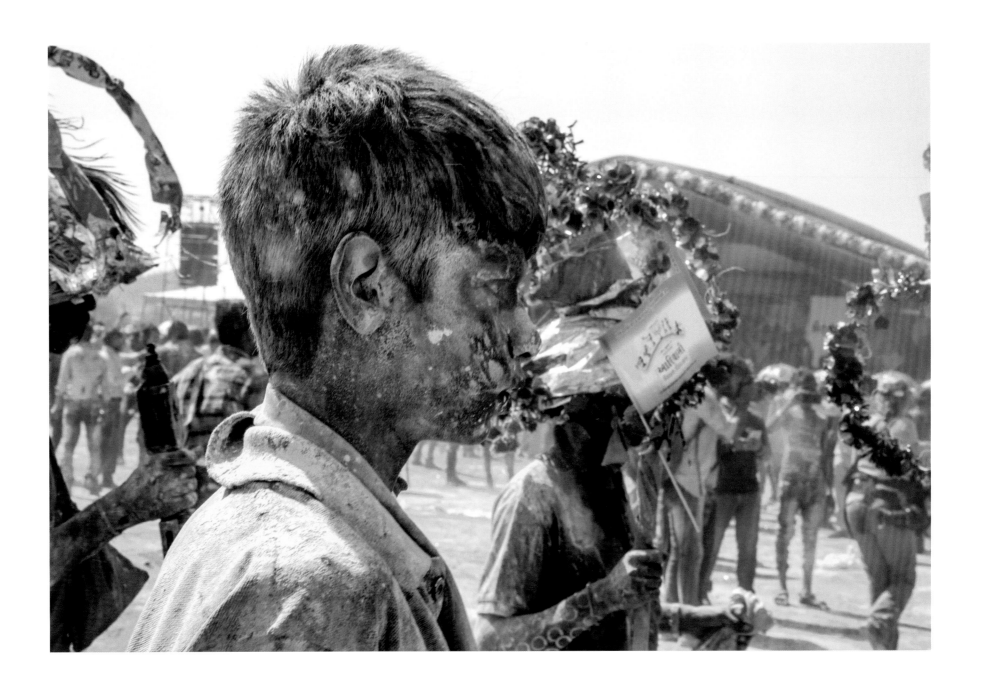

Young Holi "Warrior" - Kawant, India - March 2017

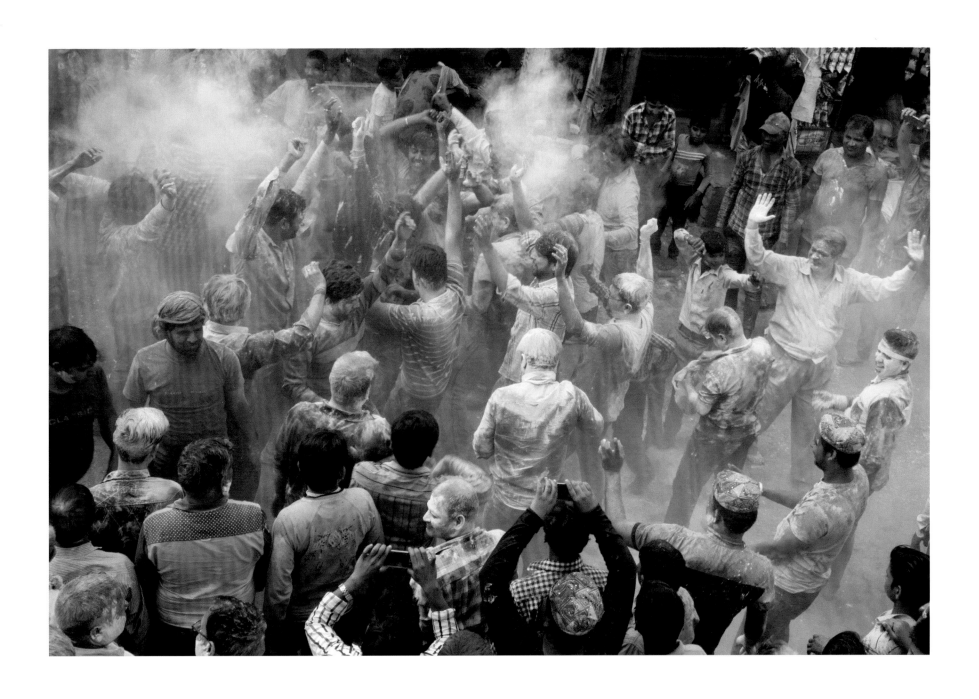

Raining Yellow Paint - Barsana Village, India - March 2017

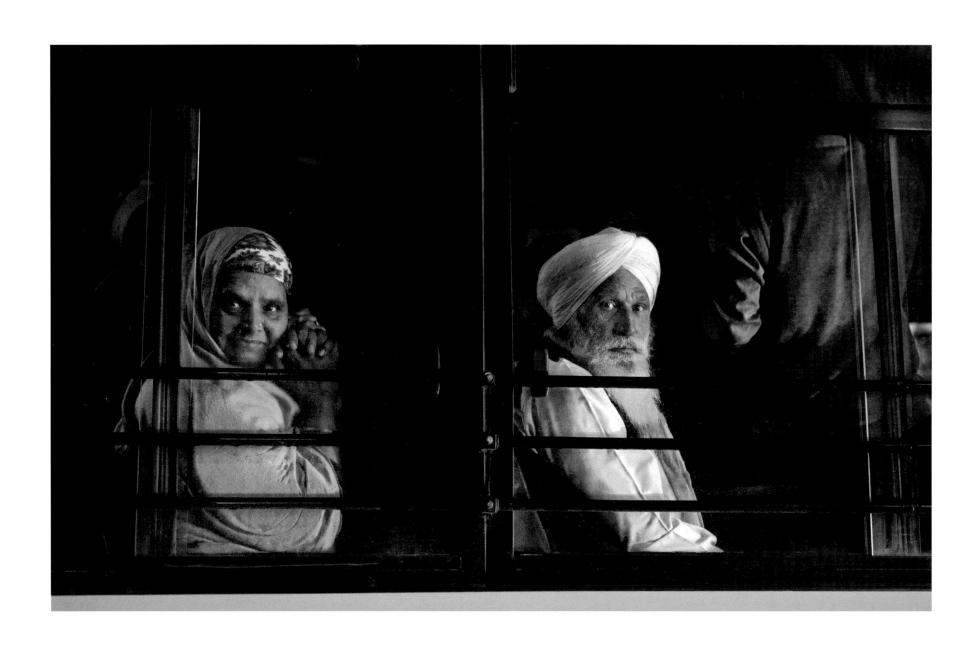

A Man and a Woman on a Bus - Amritsar, India - March 2017

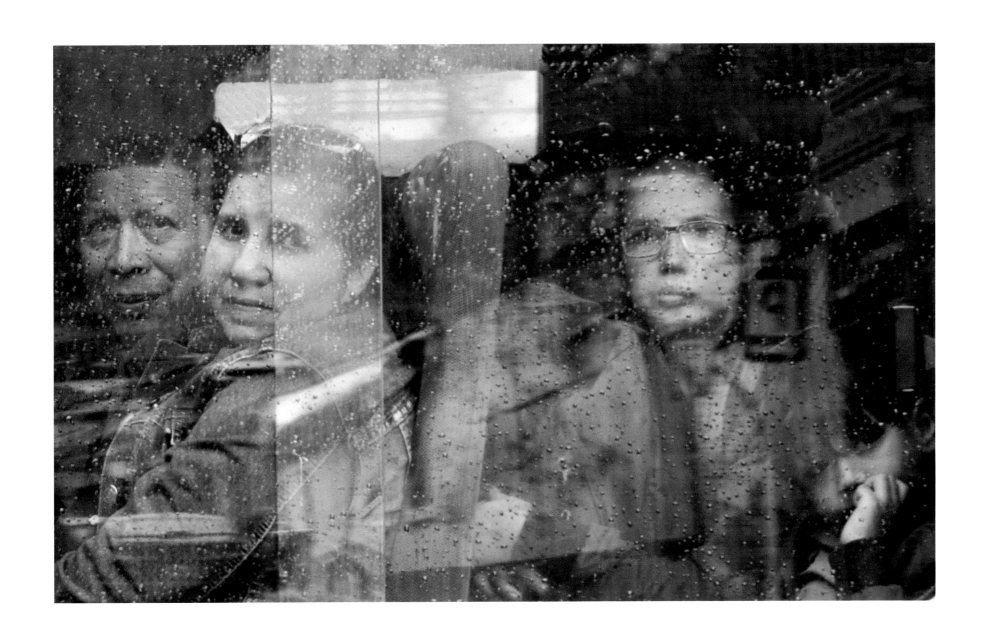

Colombians on a Bus - Bogota, Colombia - January 2019

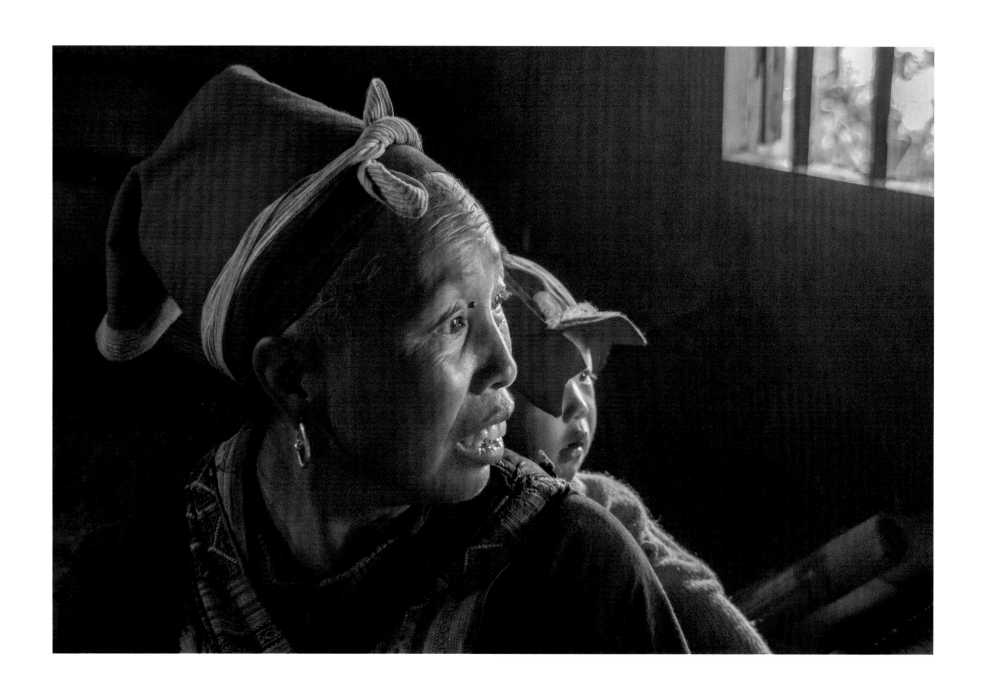

Mother and Child - Sapa, Vietnam - March 2015

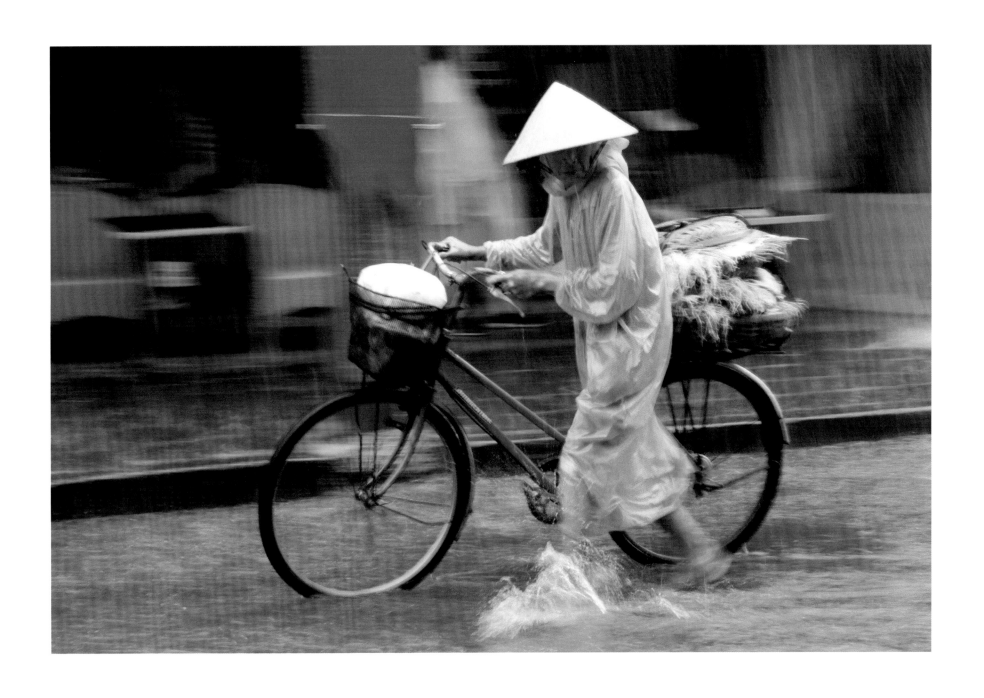

Deluge in the Street - Hoi An, Vietnam - March 2015

Route 66 was built in the late 1920s and offered a southern route to travelers heading west from Chicago and St. Louis all the way to Santa Monica, California. Known as the "Mother Road," Route 66 was incredibly popular with travelers, and towns along the way prospered. The interstate highway system replaced segments of Route 66, but the culture of the Mother Road remains. It is this culture that drew us for a three-week road trip.

All along the way we stayed at original motels and ate in classic diners. We loved experiencing the life of travelers from the 20's and 30's. We treasured the old cars with original hood ornaments, kitsch, friendly waitresses and restored gas stations.

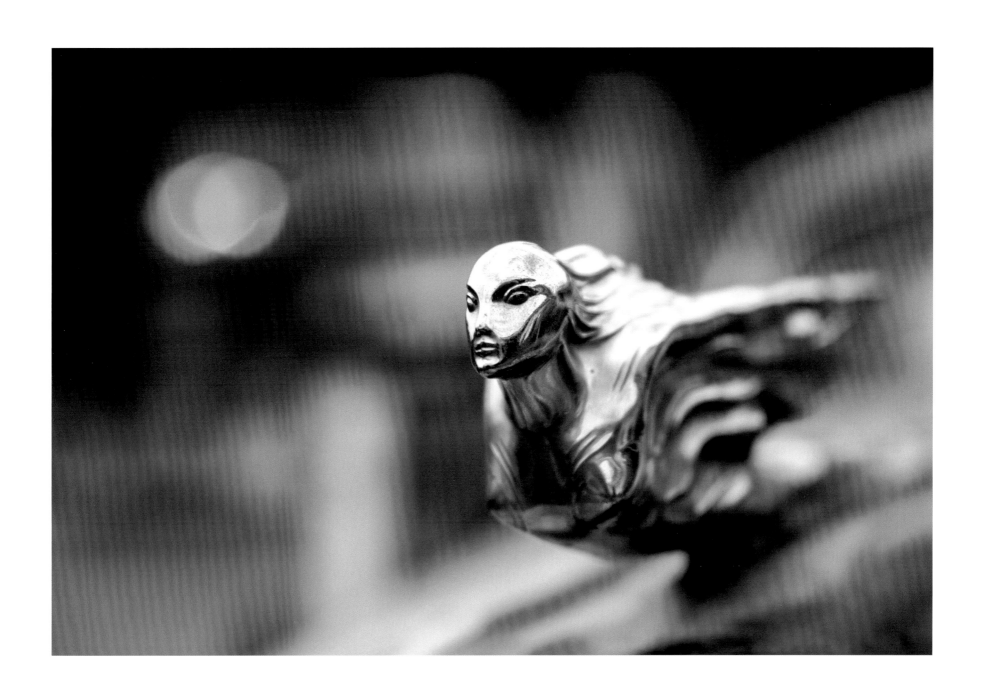

Cadillac's 1953 Flying Lady - Barstow, California - August 2017

Twistee Treat Queen - Livingston, Illinois - October 2018

Preserved Textile Mill Staircase - Lowell, Massachusetts - October 2008

Times Square Sidewalk Reflection - New York City, New York - July 2011

Route 66 Diner Waitress - Albuquerque, New Mexico - August 2017

Hotel Check In - Fort Peck, Montana - June 2016

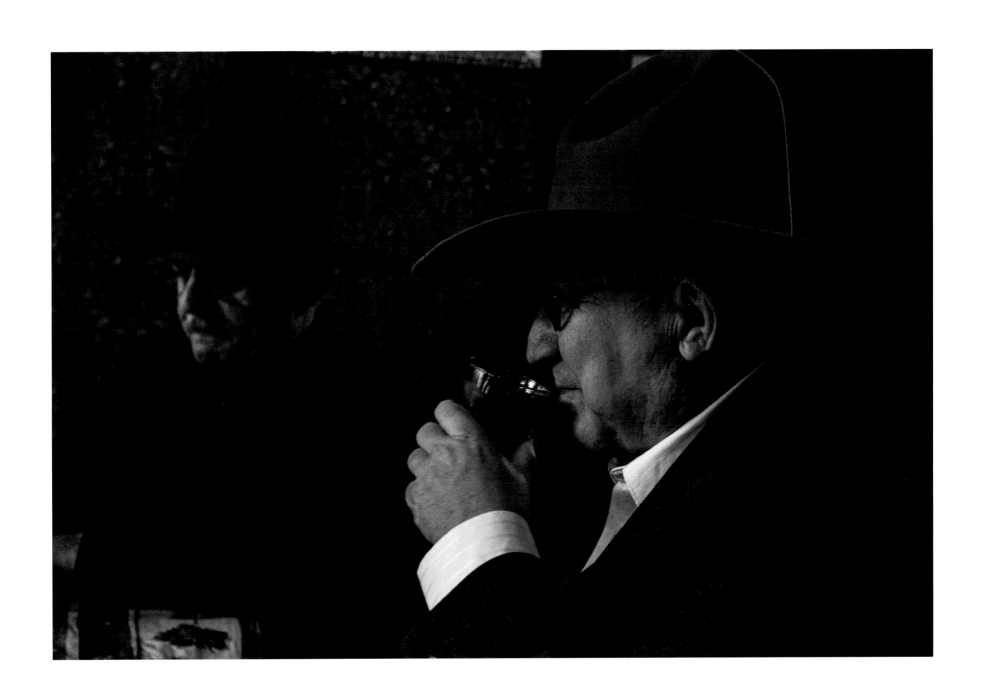

Two Gentlemen Enjoy a Moment - Buffalo, Wyoming - June 2016

Route 66 was broken into pieces when the interstate highway system was built during the Eisenhower administration. Fortunately, long stretches remain intact and are preserved. At one point we had a choice. Turn right to continue west on Route 66 or turn left down a dead-end spur to see a small piece of the original highway.

We chose the dead end, and just a mile down the road, we came upon this well-preserved, but deserted, old gas station. I took a lot of photos. The flat light and colors reminded me of the painter, Edward Hopper. Later I posted the photograph on the opposite page. I made no mention of Hopper. The first response said "very Hopperesque" and a few responses later a friend posted the photo seen below, into which he had Photoshopped a woman from one of Hopper's paintings.

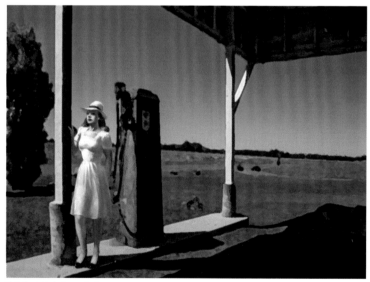

Photo illustration by Duncan MacGruer

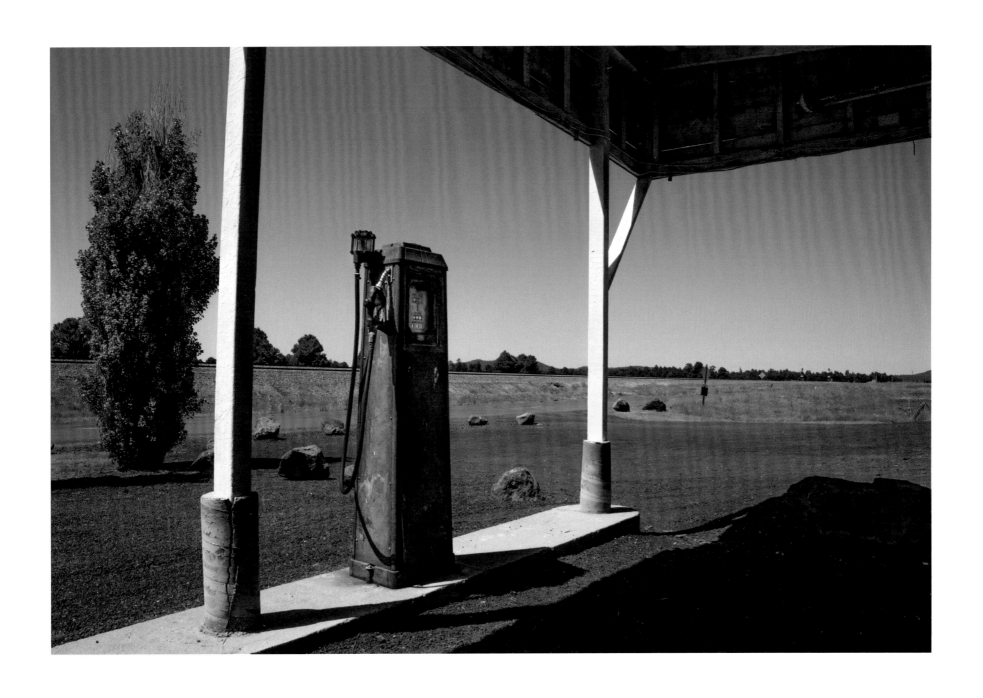

21 Cents a Gallon - Route 66 Detour, Near Ash Fork, Arizona - August 2017

It was September 7, 2016, and Sally and I were wandering the streets of Clarksdale, Mississippi. Barbershops are a good gathering place for locals, and we stepped into this brightly colored one, hoping to talk to folks and take photographs. The barber, clad in a red t-shirt, said we could not take photographs. Sally left and, with permission, I just sat and observed.

About ten minutes later, the barber disappeared into the back room. He returned in a few minutes, now wearing his more formal black barber's shirt, and announced, "Now you can take my picture!"

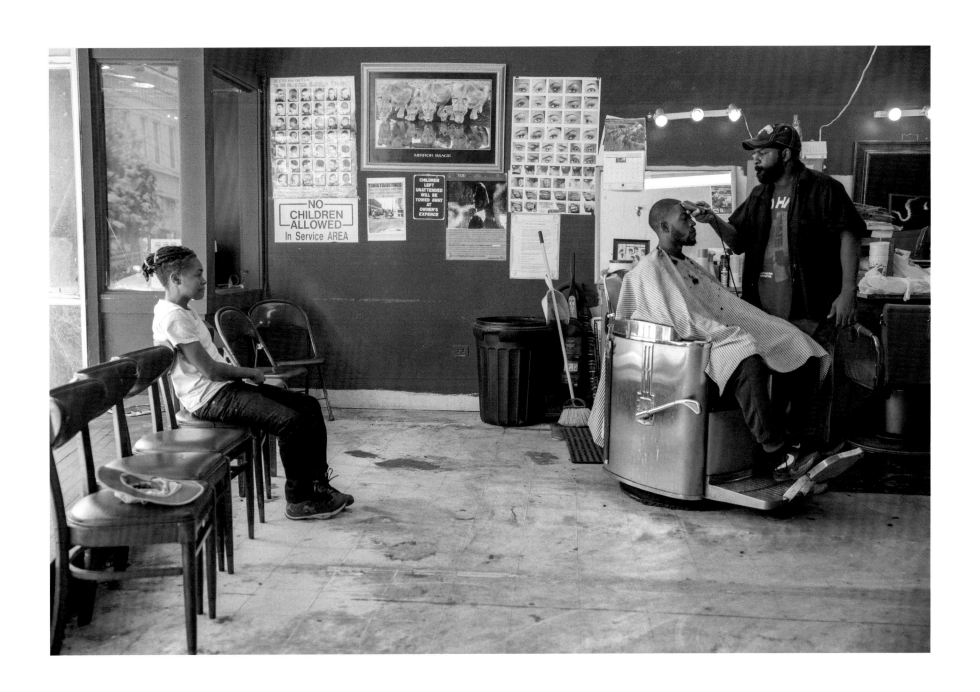

Barbershop - Clarksdale, Mississippi - September 2016

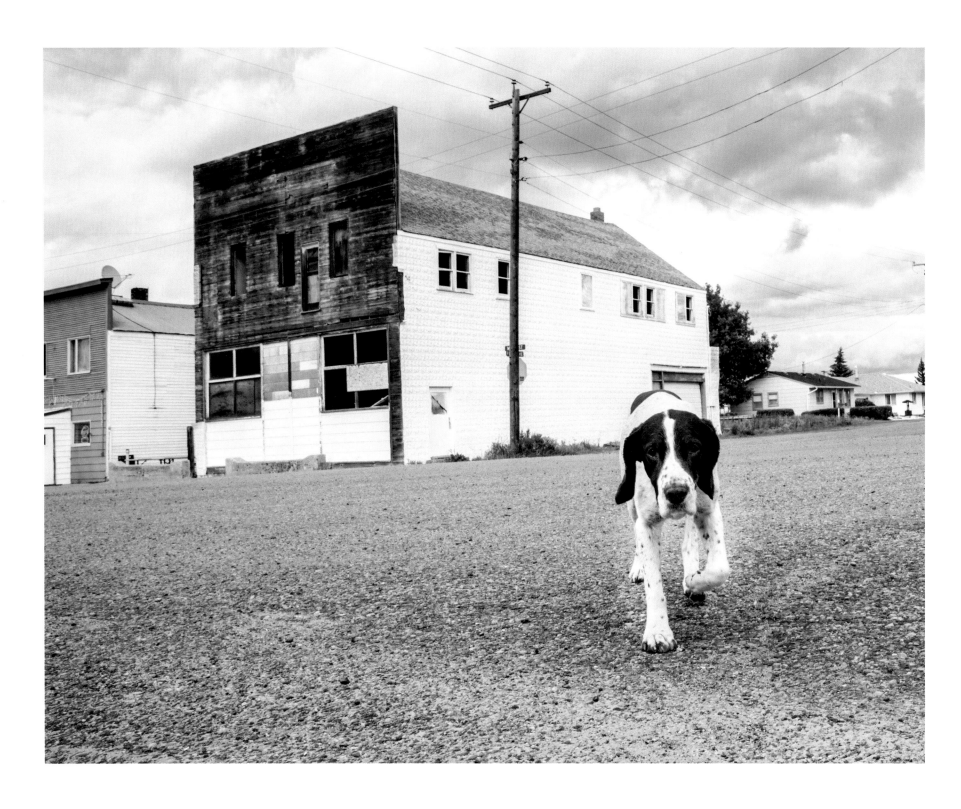

Ghost Town Hound - Flaxville, Montana - June 2016

We were in Flaxville, Montana, a nearly deserted town with a population of 71 in northeastern Montana. The town's only restaurant is the Bum Steer, where we had our standard small-town fare of a hamburger with American cheese and a nice cold brew. There was not a lot to see, but in a small town like Flaxville, there's always a good photograph to be found.

I was walking down Main Street when I saw this beautiful spaniel. I pointed the camera at him, but he spooked and ran to the far corner of the intersection. I still wanted the photo, so I sat on the curb, lowered the camera between my legs and waited to see what would happen. The spaniel eventually ventured back toward me. I imagined him saying, "Now you can take my picture." Without raising the camera, I clicked away, hoping one of my shots would be in focus and framed properly. He was probably four or five feet away when I took the photograph shown on the opposite page. I like his movement toward me and the desolate look of the building in the background.

The spaniel walked over to my side, sat down, and Sally took the photo below as my new "Best Friend" leaned against me.

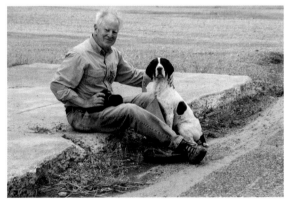

Photo by Sally Harris

Acknowledgements

The thought of making a book about my photographs began several years ago, but procrastination took over. I like to photograph so many different things, that I struggled even selecting the genre for the book. My friend Jerry Pollack would regularly urge me to get started. Thanks Jerry. About a year ago I committed to make a book and began the process of selecting and sequencing my work. I had not imagined the effort of sorting through thousands of possibilities and the work that the process entailed. In the end, I knew I wanted the book to be about culture and people.

Friends have been incredibly helpful in reviewing potential selections for the book, weeding out the undesirables and identifying the keepers. Thank you, Jean-Marc Bara, Deb Bohren, Saman Majd, Skip Klein, Steven Lingeman, Charlie Seton, Debbie Wolf and Bernie Wruble for your time and your honesty. You truly made a big difference. Thanks too, Jean-Marc, for suggesting the title, which helped me shape the entire book.

I want to acknowledge and thank Leslee Asch for helping me through the publishing process, including the selection of Friesens as the printer.

My wife, Sally, and I are inseparable soulmates and living out our common passion for photography. One summer, we spent five weeks together in a car driving from Seattle to the Dakotas and back. Stopping every few miles to photograph something one of us spotted. Never a sharp word, just respect for each other every step and every motel along the way. Sal, thanks for sharing my passion. Our mutual interest changed our lives. I look forward to reading your book.

My two daughters, Ashley and Brooke, are both photographers in their own right, and each has a great eye for a good shot. Thanks for listening to me talk about this book perhaps endlessly. And thanks for your interest and valuable input as the project moved forward.

My photography life began in a workshop with Eddie Soloway. Eddie nurtured my interest in photography, as well as Sally's. We have enjoyed our special times with Eddie. His gentle manner and grace are so welcome in our hectic world. I was honored when Eddie agreed to write the introduction for the book. Eddie, thanks for all you have done for Sally and me.

Sally and I have loved travelling with small groups of photography enthusiasts to far flung corners of our world. Professional photographers organized these trips to exotic locations and made sure participants had access to special photographic opportunities. I want to thank Joseph-Phillippe Bevillard, Richard Martin, Magdalena Solé, Peter Turnley and Nevada Wier for writing very special descriptions accompanying several of my photographs.

Everyone says you need an outstanding editor to create the book you have dreamed about. I met Michael McWeeney at a bookmaking workshop in January 2020. I liked his approach to bookmaking and resolved to get back in touch when I was ready. To my delight, Michael agreed to work with me, and his dedicated work and ideas have been invaluable. Thanks also to Eileen AJ Connelly who acted as my copy editor. In that role, she did much more, refining my presentation and the natural flow of my words.